Compass in Hand

Selections from The Judith Rothschild Foundation Contemporary Drawings Collection

Christian Rattemeyer

The Museum of Modern Art, New York

BNY MELLON

The Bank of New York Mellon is proud to be the lead sponsor of the exhibition *Compass in Hand: Selections from The Judith Rothschild Foundation Contemporary Drawings Collection*, and of The Museum of Modern Art's contemporary art collection installations through 2012.

We are particularly excited that this collection features work by artists from over forty different countries. As a globally diverse company, we hope that exhibits such as this encourage and enhance cultural life and diversity in our communities—helping them to continue to be the best places to live and work. We sincerely hope that you enjoy all that this valuable collection has to offer.

Foreword

Since its inception in 1929 The Museum of Modern Art has been the recipient of the unparalleled generosity of dedicated Trustees and passionate collectors. Beginning with Lillie P. Bliss and Abby Aldrich Rockefeller, two of our founders, some of the institution's most significant acquisitions were donations made by private individuals and institutional collections. Following in this impressive tradition, Harvey S. Shipley Miller, Trustee of The Judith Rothschild Foundation and a member of the Committee on Drawings and the Board of The Museum of Modern Art, gave to the Department of Prints and Illustrated Books, on behalf of the foundation, a seminal collection of Russian avant-garde books in 2001. In March 2003 Miller began another incredible philanthropic undertaking: a contemporary drawings collection that would form a survey of drawing practices at a specific moment in time. He conceived the collection with the idea that it would be donated to an institution, and we are incredibly fortunate to have it here at MoMA.

The Judith Rothschild Foundation Contemporary Drawings Collection was formed with remarkable effort over two years by Miller in close consultation with Gary Garrels, formerly The Robert Lehman Foundation Chief Curator of Drawings and Curator of Painting and Sculpture at The Museum of Modern Art (now the Elise S. Haas Senior Curator of Painting and Sculpture at the San Francisco Museum of Modern Art), and consulting curator André Schlechtriem; it is made up of some 2,500 works by over 650 artists, and it is the largest gift ever made to the Department of Drawings. Even more extraordinary is that this collection has introduced over 300 new artists to the Museum's collection, and more work by many of them has since been acquired, in drawings and in other mediums.

Compass in Hand: Selections from The Judith Rothschild Foundation Contemporary Drawings Collection is the first comprehensive presentation of this transformative gift. This publication and accompanying exhibition, thoughtfully organized by Christian Rattemeyer, The Harvey S. Shipley Miller Associate Curator of Drawings, with Connie Butler, The Robert Lehman Foundation

Chief Curator of Drawings, proudly celebrates the collection and provides a panorama of the state of drawing today. The exhibition focuses particularly on two manifestations of artistic practice, both of which became apparent to the curators while studying this collection: the notion of drawing as a conceptual exploration of mark making and as representational image making. The exhibition is organized by time periods, artistic movements, and geographic locations, the principles on which the collection was generally based, and includes contemporary works by Kai Althoff, Peter Doig, Marcel Dzama, Mark Grotjahn, Charline von Heyl, Christian Holstad, Roni Horn, Paul McCarthy, Jennifer Pastor, Kara Walker, and Andrea Zittel, to name just a few. Some artists, such as Jasper Johns and Cy Twombly, are represented by examples of recent work, while others, such as Joseph Beuys, Alighiero e Boetti, and Martin Kippenberger, are highlighted through a more in-depth selection, and still others, such as Ray Johnson, Anish Kapoor, and Franz West, are shown in a comprehensive overview of their careers. An exceptional selection of Minimal and Conceptual drawings from the 1960s and 1970s, originally from the collection of Eileen and Michael Cohen, and works by significant outsider artists such as Henry Darger, James Castle, and Pearl Blauvelt form thematic groupings of historic abstraction and figuration, respectively, addressing both sides of the exhibition's focus.

In tandem with Miller's extraordinary connoisseurship, Garrels's sensitive understanding of and commitment to the Museum's collection and institutional mission helped shape this collection. His keen eye and vast knowledge of the international contemporary art scene and the art historical context from which it developed has left an enormous imprint on this collection, and I deeply admire the expertise, enthusiasm, and judgment he contributed during his time at MoMA. Schlechtriem was invaluable to The Judith Rothschild Foundation as this project's consulting curator, and his particular knowledge of the emerging artists in Germany is evident. The acquisition and presentation of this collection was also an enormous undertaking, and this exhibition and catalogue would not have been possible without the dedication of the organizers, along with the Department of Drawings curatorial team: Kathy Curry, Assistant Curator, Research and Collections; Maura Lynch, Curatorial Assistant; Carrie Elliott, Research Assistant; Eleanor White, Preparator; and John Prochilo, Department Manager, along with Scott Gerson, Assistant Paper Conservator, and David Allison, Project Collections Photographer. The entire staff of the Department of Drawings has worked on this project since its arrival at the Museum and has seen it come to fruition in this exhibition and catalogue.

I would also like to thank The Bank of New York Mellon for its generous sponsorship of the exhibition.

Above all I am immensely grateful to Harvey S. Shipley Miller, a friend of the Museum and a generous patron of the arts, whose dedication, imagination, and expertise have had a profound impact on the Museum's collection and on the way we think about drawing.

Glenn D. Lowry
Director
The Museum of Modern Art, New York

Acknowledgments

This is the largest exhibition of drawings ever mounted at The Museum of Modern Art, and perhaps one of the largest in the history of the medium. Any project of this scope demands a team of committed individuals and an institutional ethos behind it. I extend deep gratitude to many people at the Museum who were closely involved with this project since its inception. Glenn Lowry, Director, enthusiastically supported this collection from the very beginning of its formulation and its subsequent acquisition by the Museum. More recently Kathy Halbreich, Associate Director, wholeheartedly embraced the collection, and Jennifer Russell, Senior Deputy Director for Exhibitions, Programs, and Collection Support, was, as always, unflinching in her support for all aspects of this exhibition's organization.

I would like to acknowledge the Museum staff who have made invaluable contributions to this exhibition and publication. In the Department of Publications: Christopher Hudson, Publisher; Kara Kirk, Associate Publisher; David Frankel, Managing Editor; Marc Sapir, Production Director; Emily Hall, Associate Editor; and Libby Hruska, Editor, all of whom contributed great expertise and care in managing and shaping this voluminous project. Carey Gibbons, Assistant to the Publisher; Bryan Stauss, Assistant Business Manager; and Hannah Kim, Coordinator, also helped on various aspects of this publication's production and distribution. Outside the Museum, Adam Michaels and Molly Sherman at Project Projects have designed a beautiful catalogue that is sensitive to the diversity of works in the exhibition.

In Imaging Services, tremendous thanks go to David Allison, Project Photographer for the Rothschild collection, who approached each work with great attention to detail, resulting in expert documentation. Erik Landsberg, Head of Collections Imaging, and Robert Kastler, Production Manager, were always willing to accommodate our requests and wonderfully managed this large project. Roberto Rivera, Production Assistant, and Rebecca Greenberg, Digital Image Archivist, were constantly inundated with imaging requests and always provided assistance promptly and with good cheer.

Carlos Yepes, Associate Coordinator of Exhibitions, was incredibly helpful in navigating all of the logistics of the exhibition. David Hollely,

Production Manager in the Department of Exhibition Design and Production, designed a wonderful gallery space, and throughout the exhibition process he patiently reviewed floor plans and installations. Michele Arms, Department Manager, was also of great assistance.

In the Department of Registration, Ramona Bronkar Bannayan, Director, Collections Management and Exhibition Registration; Susan Palamara, Registrar; Whitney Snyder, Associate Registrar; Brandi Pomfret, Registrar Assistant; Rob Jung, Manager, Art Handling and Preparation; and Sarah Wood, Assistant Manager, Art Handling and Preparation, seamlessly worked on transporting the works and saw that they were treated with the utmost care. I also want to especially thank the team of preparators at MoMA QNS: Paul Abbey, Steve Burkart, Matt Lucas, Alex Rudinski, Steve West, and Andrew Zimmerman always handled the artwork with extreme care and worked with us with great patience. In Collection and Exhibition Technologies, Jeri Moxley, Manager; Eliza Sparacino, former Manager; Ian Eckert, Coordinator; Susanna Ivy, former Coordinator; and Kristen Shirts, Assistant, were incredibly helpful in keeping organized all of the catalogued information. Peter Perez, Framing Conservator, advised on the framing of a majority of works included in this collection, an enormous undertaking, and the extraordinary talent of Bill Ashley, Carlos Carcamo, Cynthia Kramer, Polly Lai, John Martin, and Matt Osioli in the frame shop is evident in the elegant presentation of the works on view.

On legal matters, much appreciation is extended to Patty Lipschutz, General Counsel, and Stephen Clark, former Associate General Counsel, who were deeply involved with the collection in its earliest stages of acquisition. Nancy Adelson, Associate General Counsel, and Dina Sorokina, Paralegal, were incredibly responsive to our queries and were of great assistance on all copyright issues.

Elsewhere in the Museum are indefatigable staff who have helped and assisted in various ways. I would especially like to thank, in the Department of Education, Pablo Helguera, Laura Beiles, and Sara Bodinson; in Communications, Kim Mitchell and Daniela Stigh; in Development, Mary Hannah, Todd Bishop, and Rebecca Stokes; in the Office of the Director, Diana Pulling; in Graphics, Claire Corey; in the Library, Milan Hughston, Jennifer Tobias, Sheelagh Bevan, Ian Goulston, David Senior, Philip Parente, and Alexa Goldstein. Iris Schmeisser, Curatorial Assistant in the Department of Prints and Illustrated Books, was invaluable with translation assistance. A special mention also goes to our interns Maria Alberola Boada, Jillian Davies, Carmen Hermo, Stephanie Kistner, Riccardo Pillon, Francesca Pistone, Ryan Reineck, Francesca Sonara, and Casilda Ybarra Satrustegui, who assisted at various stages of this exhibition and publication.

An exhibition incorporating a wide array of artists demands a tremendous amount of research and cataloguing, which would not have been possible without the help of our numerous colleagues outside

the Museum. I would especially like to thank Frances Beatty Adler, Mitchell Algus, Anthony Allen, Brooke Anderson, Martina Aschbacher, Cristina Ayala, Douglas Baxter, Tiffany Bell, Catherine Belloy, Stacy Bengston, Rosalie Benitez, Florian Berktold, Justine Birbil, Ted Bonin, Maryse Brand, Angela Brazda, Tanya Brodsky, Chana Budgazad, Jennifer Burbank, Gisela Capitain, Jessie Chien, Donna Chu, Mary Clare, Michael Clifton, Christopher D'Amelio, Cynthia Daignault, Melissa De Medeiros, Durk Dehner, Jessica Eckert, Dietmar Elger, Konstanze Ell, Ken Fernandez, Bridget Finn, Dr. Regina Fiorito, Lisa Franzen, Sarah Fritchey, Dr. Heike Fuhlbruegge, Jaime Gecker, Christoph Gerozissis, Kara Gillam, Ann Giordano, Barbara Gladstone, Marian Goodman, David Gray, Julie Green, Katie Guggenheim, Teneille Haggard, Tina Hejtmanek, Laura Higgins, Mike Homer, Miciah Hussey, Sarah Hymes, Uchenna Itam, Lisa Jo, Laura Kaesshaefer, Miriam Katzeff, Hiroko Kawahara, Erin Kermanikian, Dr. Elisabeth Klotz, Michael Kohn, Andrew Kreps, Kiyoko Lerner, Jaap van Liere, Magdalena Magiera, Paula Mazzotta, Larry Miller, Laura Mitterrand, Dr. Roger Mosesson, Wiebke Neumann, Sarah Nichols, Eric Nylund, Annie Ochmanek, Marc Payot, Heather Pesanti, Carolyn Ramo, Diana Rawstron, Katy Reed, Michelle Reyes, Darren Rhymes, Max Rifkind-Barron, Marcus Ritter, Margarete Roeder, Mirella Roma, Kath Roper-Caldbeck, Andrea Rosen, Lauran Rothstein, Jeffrey Rowledge, Amy Sandback, Maureen Sarro, Marsie Scharlatt, Hanna Schouwink, Sara Seagull, Susanna Singer, Michael Solway, Dorothee Sorge, David Southard, Meredyth Sparks, Silke Stahlschmidt, Laura Sumser, Susan Swenson, Sarah Taggart, Kelly Taylor, Lucien Terras, Andrea Teschke, Michelle Tillou, Jacqueline Tran, Courtney Treut, Lia Trinka-Browner, Andrea Überbacher-Kloiber, David Vaughan, Eva Walters, Molly Watts, James Woodward, Alex Zachary, and David Zwirner.

Exhibitions are always the result of the dedicated hard work of talented individuals, and this is especially true for this exhibition. Christian Rattemeyer, The Harvey S. Shipley Miller Associate Curator of Drawings, joined the Department of Drawings shortly after my own arrival and took on the coordination of this exhibition with open eyes and tremendous enthusiasm. Maura Lynch, Curatorial Assistant, gracefully managed all aspects of the exhibition and both publications and was unflappable throughout. Carrie Elliott, Research Assistant, and Eleanor White, Preparator, began working with this collection shortly after its acquisition. Their unparalleled knowledge of and engagement with the works has made their contribution to this publication and exhibition vital. Scott Gerson, Assistant Conservator, worked extensively to identify the mediums for all the works, and his research is a wonderful contribution to the field of conservation. Kathy Curry, Assistant Curator; John Prochilo, Department Manager; and David Moreno, Preparator, have also worked closely with the collection since 2005 and have contributed great judgment and insight. This publication and exhibition

benefited from the intelligence and wonderful camaraderie of my colleagues in the Department of Drawings: Jodi Hauptman, Luis Pérez-Oramas, Esther Adler, Geaninne Gutiérrez-Guimarães, Samantha Friedman, Tricia Paik, Alexandra Schwartz, Romy Silver, Mary Saunders, and Ji Hae Kim.

Thanks are due to Gary Garrels, former Robert Lehman Foundation Chief Curator of Drawings and Curator for Painting and Sculpture, and André Schlechtriem, former consulting curator for the Judith Rothschild Foundation, for their expertise and contribution to the collection's creation. I am tremendously grateful for the dedication and support of the Committee on Drawings and their support of this momentous collection acquisition, and for the unwavering leadership of its chairman, Kathy Fuld.

No one deserves more thanks than the artists in the exhibition and in the collection. Their work and dedication is where it all begins, and all of them have contributed knowledge, dispensed advice, and answered questions, often numerous times, as we have gone through the phases of incorporating the collection into the Museum's holdings, gradually acquiring a better understanding of each and every work. All of the artists have been formidable stewards of their creations, and we try to honor their work with ours.

Finally, I thank Harvey S. Shipley Miller, our great supporter and friend of drawings. I have rarely met an individual with such innate intelligence about art and singular passion for museums as the stewards of history. It has been a privilege to begin to understand this great collection's implications for contemporary art history; they are a tribute to his vision.

Cornelia Butler
The Robert Lehman Foundation Chief Curator of Drawings

Compass in Hand:
Assessing Drawing Now
Christian Rattemeyer

Compass in Hand presents an extensive selection of works from The Judith Rothschild Foundation Contemporary Drawings Collection, an extraordinary treasure trove of 2,500 works on paper by more than 650 artists, which was acquired by The Museum of Modern Art, New York, in May 2005. Although several works from the Contemporary Drawings Collection have already been exhibited at the Museum in other contexts—and the seamlessness with which the collection has merged with and complemented the Museum's holdings is a particularly fortunate demonstration of its value to the institution—*Compass in Hand* is the first time that works representing the range of the collection have been given their own study and review.

 This exhibition cannot possibly represent the entire collection and in fact only features about ten percent of it. Even the shape of the collection, its multifaceted nature, cannot be adequately laid open in a single exhibition. But I hope that this exhibition may serve as a first guide into its vast inner reservoirs, touching on the core principles that have determined its gestalt and philosophy. At the same time, I am certain that future engagement with the materials that make up The Judith Rothschild Foundation Contemporary Drawings Collection will bring forth more detailed and focused readings and will generate different interpretations of its parts and whole.

 The collection was the brainchild of Harvey S. Shipley Miller, the Trustee of The Judith Rothschild Foundation and a member of the Committee on Drawings and of the Board of The Museum of Modern Art. Miller began to assemble the collection in early 2003, intending it as a one-year project (eventually extended by another year) in which he would create, as he said in an interview included in this publication (page 30), "a cross-section of a moment in time," panoramic in overview, contemporary in focus, inclusive in nature but not meant to be encyclopedic. Miller amassed it with the intent of donating it to a New York museum, preferably MoMA. From the start, Gary Garrels, then The Robert Lehman Foundation Chief Curator of Drawings and Curator of Painting and Sculpture at The Museum of Modern Art, acted as Miller's chief advisor and constant interlocutor, and André Schlechtriem, then an independent curator based in New York, was hired

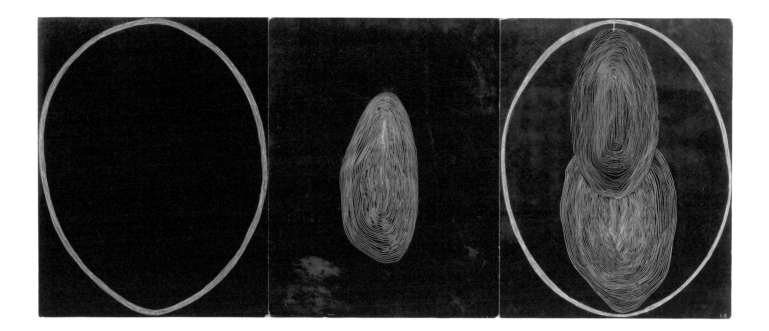

to serve as the collection's coordinator. In May 2005 the Committee on Drawings at The Museum of Modern Art voted on the acquisition and accepted it into the collection of the Museum.

Preceding the formal decision to begin the project, and arguably the first purchase toward the collection, was Miller's acquisition, in March 2003, of a single drawing by Chloe Piene. The decision to assemble a collection of contemporary drawings was made soon afterward, and this first purchase was quickly followed by a marked increase in intensity that would last for the entire span of the project. The dedication, urgency, and expertise of Miller and Garrels—as well as their timing and good fortune and the outside support they received—all shaped and contributed to this collection. In many ways it is a feat that could not be repeated today and remains a singular effort of its time.

From the beginning, Miller and Garrels decided to focus the collection on several key centers of production, places that at that moment were particularly fertile: New York, Los Angeles, Great Britain (with London and Glasgow as centers), and Germany (with Berlin as the current center and with Cologne and Düsseldorf as historically significant cities). The collection provides a selection of the most relevant current tendencies of works on paper and represents the broadest possible overview of the different ways a drawing is conceived, made, used, and categorized. The materials range from traditional mediums such as graphite, pencil, watercolor, gouache, synthetic polymer paint, oil paint, and various print techniques to a broad range of assemblage, collage, and found objects, as well as rubbings and transfers of soil, pigments, plant extracts, soot, foodstuffs, and body fluids. There are studies and sketches as well as monumental finished works; there are works painstakingly produced with the help of technical tools such as rulers, as well as spontaneous scribbles with

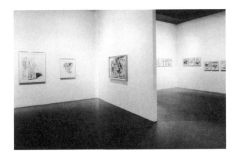

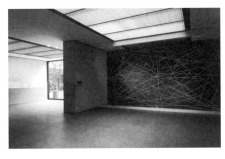

no particular regard for finish; and there are narrative and figurative works along with a broad range of abstractions, from the minimal to the gestural.

Among the artists represented in the collection are many of the twentieth-century greats, such as Ellsworth Kelly, Roy Lichtenstein, Andy Warhol, Jasper Johns, Robert Rauschenberg, Cy Twombly, Joseph Beuys, Georg Baselitz, Alighiero e Boetti, Mario Merz, Donald Judd, Agnes Martin, Edward Ruscha, Louise Bourgeois (fig. 1), Lee Bontecou, David Hockney, Martin Kippenberger, Sherrie Levine, Mike Kelley, and Paul McCarthy. It also includes a good number of well-known contemporary artists such as Martin Creed, John Bock, Tacita Dean, Cosima von Bonin, Kai Althoff, Jim Lambie, Mark Grotjahn, Neo Rauch, Lucy McKenzie, and Paulina Olowska, and introduces into the Museum's collection artists such as Christian Holstad, Nick Mauss, Seb Patane, Amelie von Wulffen, Nate Lowman, and Frances Stark. Of the more than 650 artists represented in the Contemporary Drawings Collection, nearly 350 are new to MoMA's collection. The presence of so many young artists not only attests to a significantly changed attitude toward risk and experimental spirit but also shifts the balance of the Museum's collection of drawings, so that it is now almost evenly distributed among modern, postwar, and contemporary art.

Compass in Hand speaks first and foremost to the vitality of drawing today, documenting a resurgence of the medium's importance to contemporary art practice over the past two decades. It follows in the steps of a number of outstanding and important exhibitions dedicated to drawing at The Museum of Modern Art, in particular two exhibitions that have had a direct and palpable impact on the shape of the conversation about drawing as well as on the shape of the Contemporary Drawings Collection. Both were devoted to periods of great innovation, importance, and prosperity for drawing, periods in which the role, self-regard, and ambition of the medium changed and amplified. Both set the tone for the discourse about drawing's core tenets and applications during their respective periods, and every large-scale presentation of drawings at The Museum of Modern Art acknowledges their legacy. *Drawing Now*, Bernice Rose's now-classic 1976 exhibition (fig. 2), carefully considered the slow blossoming of the medium from the supporting role of study and sketch into a fully independent medium that was ideally suited, in the period that began in the mid-1950s, to the process-oriented works of post-Minimal and Conceptual art. *Drawing Now: Eight Propositions*, a 2002 exhibition organized by Laura Hoptman (fig. 3), documented another sea change in drawing, this time proposing a return to narrative and finish, to fantasy and figuration—a position closer in spirit to the romantic and academic traditions of the nineteenth century than to the radical innovations of the 1910s and 1960s. Both exhibitions were contemporary evaluations guided by the dramatic changes observed

17

at the time by the curators, and evoking their accomplishments is
a logical and obvious first step for any large-scale exhibition of drawing
at The Museum of Modern Art.

In the catalogue accompanying her exhibition, Rose unfolds a
history of drawing from the early Renaissance up through the mid-1970s,
tracing the development of drawing's dual definition, since the sixteenth
century, as "both a poetic and scientific discipline."[1] On the one hand,
drawing was *disegno*—a term that encompasses both the intellectual
activity of design and the manual act of drawing—an activity of ideation,
of bringing into the world a previously imagined design. On the other
hand, drawing was what Rose calls "graphological disclosure"—
"an autographic (indeed biographical) revelation, presenting the artist's
first and most intimate and confessional marks."[2] These two activities,
one conceptual and the other inextricably linked to the physical
and individual capacity of the artist—to his or her hand, mark, and
skill—together formed the dual principle of drawing as a medium of
intellectual exploration and private expression, intimate in use
and modest in scale but capable of conjuring vast inner worlds. Rose
goes on to describe how the medium has alternated, roughly since
Impressionism, between these two basic capacities, in various forms.
And as drawing continued to be uncoupled from representation, first
in the avant-garde practices of early modernism and then in the art
of the postwar period, artists' attitudes toward line drawing changed, in
a philosophical move away from drawing's relationship to representation
and abstraction—its "scientific" aspects—toward the gestural and the
mark-making process, shifting the balance from the ideational toward
the autographic. This shift, with its emphasis on coloration and
facture, peaked during the immediate postwar period with the artists
of Abstract Expressionism, but by the mid-1950s the next generation

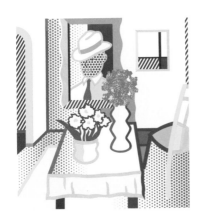

of artists—among them Johns, Twombly, Warhol, Rauschenberg, Beuys, and Lichtenstein (fig. 4)— introduced a second shift, away from drawing as intimate graphic disclosure and toward mark making that derived from the application of systemic processes and the activation of the medium's material qualities. "The story of drawing from the mid-1950s onward," Rose writes, "is the story of the gradual disengagement of drawing from autography or graphological confession and an emotive cooling of the basic mark, the line itself."[3] She continues:

> Two innovations had been at the core of the art of the late forties and the fifties. Both were graphic in origin. The first of these was Surrealist automatic drawing, which was based on the principle of drawing as graphological disclosure, on the vitality of the moving hand. Here, however, the objective was to draw without conscious control, to introduce pure chance and "the unreasonable order" of dream images into the making of art. As a technique automatic drawing produces a scrawling, random linear configuration antithetical to the idea of structured, hierarchical relationships. It tends toward abstraction rather than description. The second of these innovations is the "collage aesthetic." Invented by Max Ernst, it has its origin in traditional Cubist collage, but in Ernst's hands collage became visionary: the juxtaposition of unrelated images, by whatever means possible, for the creation of a hallucinatory image.
>
> The first of these inventions is the basis on which the drawing of Joseph Beuys and Cy Twombly is founded.... For Rauschenberg the second plays an important part in the maturation of his imagery.[4]

The liberation of drawing from subservience to other disciplines—primarily painting—throughout the nineteenth century and the radical expansion of its possibilities in the first half of the twentieth century went hand in hand with this gradual redefinition of the autographic mark, away from "graphological confession" and toward a focus on material and conceptual conditions. From the mid-1950s to the mid-1970s, drawing entered one of its most productive and influential periods, ideally suited as it was for the conceptually rigorous and materially rich practices of post-Minimalism and Conceptual art.

The Judith Rothschild Foundation Contemporary Drawings Collection begins with this momentous period for drawing and contains many artists who were featured in Rose's exhibition. Of the more than forty artists who were featured in *Drawing Now*, close to thirty are represented in the Contemporary Drawings Collection, with such central figures as Beuys, Twombly, Rauschenberg, and Johns, as well as major representatives of Minimal art, post-Minimalism, and Conceptual

19

art, such as Kelly, Martin, Palermo, Mel Bochner (fig. 5), Hanne Darboven, Dan Flavin, Eva Hesse, Donald Judd, Sol LeWitt, Robert Mangold, Bruce Nauman, Fred Sandback, Richard Tuttle, and Lawrence Weiner. The culmination of the procedure- and systems-based practices that Rose highlighted in 1976 is represented in the collection by exceptional works by American artists such as Jo Baer, Ree Morton, and Douglas Huebler; European artists such as Öyvind Fahlström and Marcel Broodthaers; and On Kawara, a Japanese artist working in Europe and the United States. The extensive range of artistic practices presented in *Drawing Now* is further expanded with artists such as Ray Johnson, who was at that time of Rose's exhibition still outside the accepted canon and has only recently been recognized as part of the period's discourse, or such as Bontecou, who was active all during that period but sequestered herself from the art world in rural Pennsylvania. Artists such as Bontecou, Johnson, and Bruce Conner are represented with major holdings from nearly every period of their careers.

Rose's exhibition continued a tradition of MoMA exhibitions that presented current and necessarily somewhat speculative looks at the art practices of their times, such as Dorothy Miller's *Americans*, which she organized approximately every four years between 1942 and 1963, and Kynaston McShine's *Information*, in 1970, an overview of Conceptual art. With the title of *Drawing Now: Eight Propositions*, in 2002, Hoptman made an overt reference to Rose's achievement and clearly positioned her own exhibition among these surveys. Just as Rose had responded to a major change in the role of drawing as a material and intellectual practice between the 1950s and 1970s, Hoptman aimed to give coherence to the changes she had observed in the contemporary art world in the 1990s, championing drawing's newly prominent role after a decade and a half of relative invisibility. But as much as she paid homage to and continued Rose's undertaking, Hoptman was responding to very different creative impulses, and her exhibition drew very different conclusions.

Drawing Now: Eight Propositions featured a generation of artists who were embracing figuration and narrative, among them John Currin, Elizabeth Peyton, Julie Mehretu, Neo Rauch, Kara Walker, Shahzia Sikander, Laura Owens, and Jockum Nordström. In the introduction to her exhibition's catalogue Hoptman describes the representational (and largely planned and sketched-out) drawings by these artists as "projective" (in Yve-Alain Bois's term), meaning that "they depict something that has been imagined before it is drawn, as opposed to being found through the process of making."[5] The similarity of this concept to what Rose described as "ideational" is striking, and represents something of a swing of the pendulum away from Rose's focus on the procedural and material conditions of drawings.

The artistic approaches in her exhibition, Hoptman writes, belong to a set of drawing practices that have largely fallen out of favor "since

6
Franz Ackermann
German, born 1963
Mental Map: St. Gallen Projection. 2004
Synthetic polymer paint and pencil on paper
5 × 7 ½" (12.7 × 19.1 cm)

The Museum of Modern Art, New York. The Judith
Rothschild Foundation Contemporary Drawings
Collection Gift

7
Norbert Bisky
German, born 1970
*Auf dich kommt es an (It Depends
on You).* 2003
Watercolor and pencil on paper
16 ½ × 22" (41.9 × 55.9 cm)

The Museum of Modern Art, New York. The Judith
Rothschild Foundation Contemporary Drawings
Collection Gift

arguably the mid-nineteenth century.... The kind of autonomous drawing that is attached less to process than to finished product, that describes a specific object or state of mind, that maps a specific experience, that tells a particular story."[6] These practices are tied to academic traditions, to the popular and narrative projects of book illustration and the graphic novel, as well as to "the techniques and formal vocabularies of varieties of precision drawing elsewhere considered industrial or commercial. Such close relationships to popular cultural forms, architectural plans, scientific drawing, ornamental embellishment, and vernacular fashion illustration further distance these drawings from process-oriented work, which exists entirely in the realm of 'art.'"[7] Hoptman structures her argument around the titular eight propositions, thematic groupings providing a basic narrative order with such broad genres as science, nature, architecture, ornamentation, fashion, and popular culture, but also with more rhetorical categories such as allegory and interior imagination, what she calls (using the term with which the artist Franz Ackermann titles many of his drawings) "mental maps" (e.g., fig. 6 and page 148). Within these categories are works by twenty-six artists, all but two of whom are represented in The Judith Rothschild Foundation Contemporary Drawings Collection, many with large-scale or multipanel works that must be considered major representations of their oeuvres.[8]

Drawing Now: Eight Propositions closed on January 6, 2003, and two months later, Miller and Garrels began to assemble The Judith Rothschild Foundation Contemporary Drawings Collection. The collection extends the arguments of the exhibitions that came before it, seeking historical precedents for Hoptman's generation of artists and proposing contemporary versions of the practices Rose had observed and described. In some cases specific national references have been amplified. For example the Museum's holdings of works by young German artists Althoff and Rauch, both of them included in *Drawing Now: Eight Propositions*, was supplemented, in the collection, with a sizeable number of drawings by the more established German artists Baselitz, A. R. Penck, Jörg Immendorff, and Markus Lüpertz, as well as with work by more contemporary compatriots such as Thomas Scheibitz, Norbert Bisky (fig. 7), Marcel Odenbach, and Michael Krebber.

In other cases the collection makes explicit the influences between generations, as with Raymond Pettibon and R. Crumb, both cited by Hoptman as predecessors to the younger generation of comics-inspired artists in her exhibition, such as San Francisco-based artist Barry McGee and Japanese artists Yoshitomo Nara and Takashi Murakami, all three of whom are in the Contemporary Drawings Collection (H. C. Westermann and Caroll Dunham, who could have just as easily been included among those she cited as influences, are also in the collection). Miller and Garrels also sought references outside the art world, such as Henry Darger's meticulously drawn and

21

8
Amy Cutler
American, born 1974
Preceding. 2004
Gouache and colored ink on paper
40 ½ × 60" (102.9 × 152.4 cm)

The Museum of Modern Art, New York. The Judith
Rothschild Foundation Contemporary Drawings
Collection Gift

9
Beatrice Riese
American, 1917–2004
Sepik. 1997
Gouache, ink, and pencil on paper
28 ⅛ × 28 ⅜" (71.4 × 72.1 cm)

The Museum of Modern Art, New York. The Judith
Rothschild Foundation Contemporary Drawings
Collection Gift (gift of Dr. Roger Mosesson in honor
of the artist)

collaged two-sided works. Darger's work came to light posthumously, in 1973, when his landlord (the artist and respected art professor Nathan Lerner) cleaned out his rented room after his death. There he discovered, among other works, Darger's fifteen-volume narrative, *In the Realms of the Unreal*, comprising fifteen thousand typewritten pages and several hundred drawings and watercolors; these narrate the adventures of the seven Vivian sisters, a band of sexually ambiguous young girls threatened by the dark forces of the Glandelinian soldiers, adults who invade their innocent realm with horrible acts of violence and war. The work of many young artists, including Amy Cutler (fig. 8) and Marcel Dzama, displays an obvious debt to Darger; Dzama, who is one of the youngest artists in the collection, works in a characteristic and instantly recognizable style of figurative, almost illustrational drawing, often featuring mysterious brunettes and figures with animal heads and human bodies engaged in absurd, sometimes violent activities, set in a vaguely defined rural or post-urban hinterland.

The collection contains artists still committed to the systems-based compositional and graphological procedures of post-Minimalism and Conceptual art as laid out by Rose—artists as little known as Beatrice Riese (fig. 9) and as well established as Mark Lombardi. And there are artists who continue an experimental, exploratory, even playful relationship with their materials and mediums: Anish Kapoor, best known for his ravishingly beautiful sculptures, often deeply saturated with color, is featured with works spanning almost his entire career.

Garrels and Miller also looked at connections between artists in the two exhibitions—connections that were less obvious but later amplified by subsequent generations of artists, creating a trajectory of themes and variations surprising in its depth and revealing in its dialogues. Hockney, for example, included in *Drawing Now*, was an obvious influence on Peyton, included in *Drawing Now: Eight Propositions*. Beyond the connection between figurative artists, the Contemporary Drawings Collection creates a context for the tradition of figuration in Great Britain, with British artists such as Frank Auerbach, Lucian Freud, and Richard Hamilton, and explores an additional cultural connection through works about Britishness by the nomadic Swiss-German artist Dieter Roth, who made many works about England and completed a series of works about Francis Bacon in collaboration with Hamilton. The ideas about figuration also move beyond national and sexual boundaries: the British artist Graham Little makes delicate, exacting drawings of beautiful women clad in the latest fashions of the day, rendered in colored pencil and crayons (fig. 10), which are updated in the young Canadian artist Paul P.'s meticulous pencil and pastel portraits of adolescent boys and morbidly beautiful bouquets of flowers, often combined in tableaulike arrangements. P.'s romantic attachment to his subjects recalls Peyton, and his carefully crafted Old Master style of drawing bears comparison with Currin's drawings of

nudes with exaggerated features of beauty—one of Currin's often-cited influences is the fifteenth-century artist Lucas Cranach the Elder. The similarities of form among these artists also highlight differences of gaze; where Peyton plays with the ambiguous sexual identities of effeminate men and Currin deliberately exposes his subjects to an uneasy, perhaps sexist male gaze, P. moves the focus of his adoration clearly into the homosexual sphere. Tom of Finland, an underground artist whose highly stylized depictions of the gay leather scene represents a distinctive style of graphic sexual illustration, forms another link to this trajectory within the collection, as does Richard Hawkins, a Los Angeles–based artist whose collages riff on the theme of male desire channeled through fashion and popular culture, as well as through intimate confessional notes (and who worked for many years for the Tom of Finland Foundation).

Within the collection, such similarities and correspondences offer themselves across the spectrum of generations, geographical boundaries, formal approaches, and technical details, a Telephone-style game of styles, methods, and emotional temperature. Jennifer Pastor's precision drawings of a cowboy riding a bull—stills from an animated film, earlier versions of which were in *Drawing Now: Eight Propositions*— find a precursor in John Wesley's stenciled drawings of Walt Disney cartoon characters, which predate them by three decades. Beuys's brilliant, nervous line finds an unexpected echo in the equally intimate graphological excursions of Piene and Matthew Barney; Johns's experimental ink washes on transparent paper, with their refinement and elegance, form a trippy contrast with the virtuoso coloration of layered visual appropriations by Mauss, who is nearly fifty years Johns's junior. The emphasis on process that defined post-Minimalism, in works such as Barry Le Va's large drawings, reverberates in Grotjahn's beautiful series of colored rays radiating outward from two central, slightly offset points. Such is the richness of The Judith Rothschild Foundation Contemporary Drawings Collection that more such conversations can certainly be struck up, elective affinities can be established, and the vibrations and echoes of influences can be traced and detected with almost microscopic precision. Many more of these genealogies will surely be revealed over time—some in direct and obvious references between works, and others with more speculative yet hopeful and convincing force.

Hoptman recognized that the nature of her exhibition, however recent its works, was essentially retrospective, saying, in an interview, "Once an exhibition like this appears in an institution, things have already changed. Whatever happened, happened already. This show considers aspects of our present and recent past. I'm not suggesting this is the future. No doubt, lots of younger artists are or will be pursuing other directions."[9] It is a testament to the experimental and exploratory nature of the Contemporary Drawings Collection that Miller and Garrels

10
Graham Little
British, born 1972
Untitled. 2002
Colored pencil and gouache on paper
19 × 14 ¼" (48.3 × 36.2 cm)

continued to seek out changes to the medium right up to the moment of the collection's completion, in 2005. A change in direction is apparent in the most recent works, suggesting new approaches to working on paper, or rather with paper as a reconfigured material, in a way that neither Rose nor Hoptman discussed. Although Rose points out the importance of the Cubist collage aesthetic for artists such as Rauschenberg, this aspect is not further pursued. But in the first few years of the 2000s collage and assemblage techniques assumed a major role in art across all disciplines.

In 2002 the French critic and curator Nicolas Bourriaud applied the term "postproduction" to a new art of copying and quoting, which reflected the privileging, in various art forms, of the reusing and remixing of primary source materials (such as personal photographs) and secondary, appropriated images and materials (such as printed matter, recorded music, and digital data).[10] His models for this practice were the DJ, the film-postproduction artist (working increasingly with digital and motion-capture technology), and the software programmer—those who consider every object, sound, and image a source to be appropriated and reused. Artists, he writes, "who insert their own work into that of others contribute to the eradication of the traditional distinction between production and consumption, creation and copy, readymade and original work. The material they manipulate is no longer *primary*. It is no longer a matter of elaborating a form on the basis of a raw material but working with objects that are already in circulation on the cultural market, which is to say, objects already *informed* by other objects."[11]

The strategies of appropriation, citation, collage, and montage can range from the discrete gesture, such as the transfer of everyday objects into an art context (a process that has been part of the avant-garde vocabulary since Marcel Duchamp's readymades of the 1910s), to more selective imports of elements of found material into original work (a strategy that reaches back to Pablo Picasso's Cubist collages from the 1910s, and El Lissitzky's photomontages of the same period). And although artists have frequently employed these new methods in sculpture, installation, and digital media, many artists use them in works on paper. These works represent—rather than a rejection of drawing's traditional approaches and concerns—a new application of previous techniques and subjects. They are not against representation or narrative, but neither are they reversals of the material and process-oriented approaches of the 1960s and 1970s—and in fact they frequently encompass and borrow from those techniques. They cull from popular sources and widely distributed materials, such as fashion magazines and newspapers, but they also make references to avant-garde practices, such as those of Duchamp and Lissitzky. And they radically expand the notion of drawing from a medium of mark making or ideation or subordination to another, more finished product to a more inclusive concept of a work on paper.[12]

In this expanded definition of drawing, assemblage exists as a practice parallel with other forms of production and serves as an experimental arena in which an artist can negotiate an increasingly mediated outside world. Technological reproduction and the free circulation of images have become basic working conditions, and for many artists, entering into a dialogue with the surrounding world means aligning with image streams and the flow of information. Clipping pictures from magazines, downloading pictures from the Internet, and using one's own digital archive are no longer acts denoting a critical relationship to the autonomy of images but rather simply represent the reality of how images are produced and consumed today. For Bourriaud this is a fundamentally changed notion of authorship and production, with each artwork becoming "a temporary terminal of a network of interconnected elements, like a narrative that extends and reinterprets preceding narratives. Each exhibition enclosed within it the script of another; each work may be inserted into different programs and used for multiple scenarios."[13] Each work exists as pure process: a way station in an endless line of appropriations and rearticulations, with no definite end or product. And at the conclusion of Bourriaud's essay, at which point he is looking at works created around 2001, he points to collage as the latest expression of his thesis, a practice that brings together historical models such as Lissitzky and Duchamp with the realities of street culture and commercial mass media.

The works of New York–based artist Kelley Walker (who also collaborates with Wade Guyton, as the separate entity Guyton\Walker) are emblematic of this approach. They contain newspaper photographs and references to art history (such as, in *Black Star Press: Black Star, Black Star Press, Star* [2004; page 184], an image similar to—but not, significantly, the same one—used in Andy Warhol's *Birmingham Race Riot* [1964; fig. 11]), and they make conscious use of the role of these sources as secondary images. Walker commonly draws on his sources with coloring agents, such as toothpaste, mouthwash, and other artificially, brightly colored and readily available consumer products, and then he scans the result into a computer. The final work exists as a digital file, which can be printed out onto any surface, in any size, and in any edition desired by the user or owner. Walker feeds his work back into the circulation of images, at the same time making it clear that the copies of the digital file as individual prints are only discrete instances of it. When working as a team or, as they understand it, as a third artist, Guyton and Walker pursue related themes, replicating advertisements for vodka, airlines, and other upscale consumer products in silkscreen, and then adding graphic elements, text, and fragments of images. Each work on paper is thus unique, even though they rely on mass media sources and technologies of reproduction.

Christian Holstad, another New York–based artist, also employs newsprint, magazines, and other widely distributed printed products,

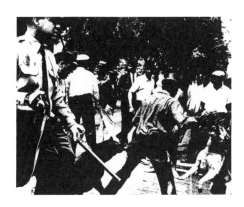

11
Andy Warhol
American, 1928–1987
Birmingham Race Riot from the portfolio
X + X (Ten Works by Ten Painters). 1964
Screenprint
19 15/16 × 24" (50.7 × 60.9 cm)
Publisher: Wadsworth Atheneum, Hartford, Conn. Printer: Ives-Sillman, Inc., New Haven, Conn., and Sirocco Screenprinters, North Haven, Conn. Edition: 500.

The Museum of Modern Art, New York. Gift of Harry C. Oppenheimer (by exchange)

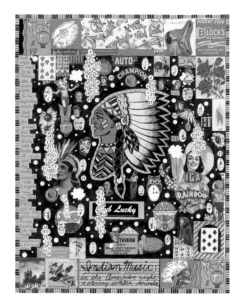

selectively erasing parts of photographs and in the process radically altering the appearance of the original. In these works removal serves as his primary composition and construction strategy, as individual elements are bleached, dissolved, and otherwise made illegible. The results are surreal and discomforting, in some instances becoming a comical or critical commentary on the original image, as in a photograph of local politicians turned into a *danse macabre* (page 214), or being altered to frightening effect, as in a photograph of prisoners transformed into a ghostly, shadowy scene that retains and even enhances the violence of the original. For his collages Holstad goes in the other direction, employing a process of addition rather than subtraction, with brightly colored magazine clippings that often depict sports icons (Carl Lewis [page 212], Mark Spitz) or young men in domestic settings, sometimes in sexually explicit poses (page 214).

For his monumental billboard collages, British artist Angus Fairhurst employed the street practice of plastering new posters directly on top of previous ones, thus accumulating something akin to sedimentary layers. But Fairhurst removed all the text and bodies from each poster, so that the layers beneath are visible through each subsequent addition's cutouts. The result of this stratification is that random compositions appear as the layers mount up, in a complex archeology of images (e.g., page 46). Johannes Wohnseifer also removes and recombines fragments culled from magazines and advertisements, but his is a more blunt message of fragmentation and rupture, created from the juxtaposition of isolated details against patterns, other images, or solid colors, all of them also ripped-out pieces of paper (e.g., page 188). In his more personal and idiosyncratic works Tony Fitzpatrick combines artifacts from popular culture (trading cards, ticket stubs, merit badges, candy wrappers, magazine clippings) with elements of drawing to create visual narratives of his life in Chicago (fig. 12).

In *Nova Popularna* (2003; fig. 13 and page 196) Lucy McKenzie and Paulina Olowska pair pages torn from design and fashion magazines with elements from iconic works of art—such as Édouard Manet's *A Bar at the Folies-Bergère* (1881–82)—to create a record of a casual bar, modeled on traditional artists' salons, that they ran in Warsaw for a short period. Because the bar, also called "Nova Popularna," preceded the collages that commemorate it, the usual process of study and product is reversed: the collages are turned into memorial objects, and the bar is understood as a part of history, much like the classic works of art the artists have used.

Not all of the artists working in this vein are concerned with the technological aspects of mediated images and the questions of endless replication and disappearance of authorial control. For some these images simply represent a starting point for further investigation of more traditional artistic interventions, as they do for von Wulffen or Patane. Von Wulffen has developed a vocabulary of found and

collected photographs that she incorporates into bold and colorful autobiographical drawings and watercolors. The found image becomes the center or core of a composition, and she then surrounds it with details suggested by the edges and borders of the frame: a continuation of an interior, a background for a closely cropped portrait, or, as in *Untitled* (2003; page 204), a bright swirl of jagged, colorful, flamelike rays radiating outward from a silent-movie siren. Patane's subtle ballpoint-pen interventions are drawn on torn-out pages of Victorian books and illustrated journals, taking the form of shaggy black wigs that mask the facial features of the rather stiff figures and make them appear almost tribal.

For Paris-based Swiss artist Thomas Hirschhorn the incorporation and reworking of appropriated materials is a very aggressive act. In the Provide Ruins series (2003; page 190), he combines images of rubble from Iraq and elsewhere, body parts from pornographic magazines, and his own obsessive overpainting and drawing in intense, hallucinatory, and slightly mad displays of aggression and violence. In Hirschhorn's hands the act of collage, itself always an act of fragmentation and removal, is amplified into a gesture of destruction and dismemberment that finds a correlation with the events depicted in the original images he employs. Rather than simply accumulative, Hirschhorn's works are also accusatory, insisting on collage's moral ground despite its strategies of amputation and mutilation.

The incorporation of appropriated materials into drawings has also significantly expanded the medium's spatial boundaries, resulting in installation-style arrangements of works on paper. Lowman's *Untitled (History of the SUV – No Blond Jokes)* (2003; page 186) fills a wall with modified images and text from articles about Lizzie Grubman, a New York publicist and socialite who, on July 7, 2001, drove her car into a crowd outside a nightclub in the Hamptons (a summer resort town frequented by wealthy New Yorkers), injuring sixteen people. With this collection of poster-sized news clippings, some pinned to the wall and others laminated on foam core, Lowman pushes the definition of drawing well into the sphere of sculpture and installation, as does Jonathan Monk in *Stop Me If You Think That You've Heard This One Before* (2003; page 234), a wall-mounted shelf displaying albums by the British 1980s cult band The Smiths, each paired with a watercolor of a round monochrome field the size of a record album.

The collection also contains an impressive selection of works by Kippenberger, McCarthy, Levine, Hawkins, Odenbach, Cady Noland, Jeff Koons, Franz West, Jack Pierson, Isa Genzken (fig. 14), and David Wojnarowicz—artists who must be seen as predecessors for this recent generation of artists working in collage and assemblage, many of whom were active in the late 1970s and 1980s. Levine in particular is closely identified with a number of artists known as the Pictures Generation (after the title of a 1977 group exhibition, focusing on appropriation and

14
Isa Genzken
German, born 1948
Fischcollage (#7) (Fish Collage [#7]). 2001
Cut-and-pasted printed paper on paper
15 3/4 × 11 3/4" (40 × 29.8 cm)

The Museum of Modern Art, New York. The Judith Rothschild Foundation Contemporary Drawings Collection Gift

the reuse of images, at the New York nonprofit gallery Artists Space), and she has been a major influence on many younger artists. The Contemporary Drawings Collection has a wonderful range of her early works. One of them, *President Collage: 1* (1979; page 158) contains an outline of George Washington cut from a fashion magazine and set against a white piece of paper. The simplicity of this gesture—an old-fashioned silhouette, a staple of bourgeois portraiture in the Victorian age—is in stark contrast with the work's disorienting effect, which catches the viewer between the profile and the image printed on the appropriated page, a young woman gazing out directly and seductively. This discrepancy creates much of the punch of the work, but its economy of means is nearly as impressive.

Kippenberger's work is the archetypal model for some of the more iconoclastic tendencies of recent collage—the knowing disregard for good taste and proper decorum, the clashing juxtapositions, the cloyingly bad humor—seen in Lowman and Wohnseifer's work, as well as in the work of British artist Sarah Lucas, who has made a name for herself with sexually charged and materially abject sculptures and collages. Noland espouses a different kind of radicalism, freely exchanging original and copy in her hard-edged sculptures from the early 1990s, which contain riot barriers, handcuffs, and images of America's radical history, from Lee Harvey Oswald to Patty Hearst, and which have influenced many younger artists, such as Kelley Walker, Banks Violette, and Monica Bonvicini. The principles of appropriation and reuse expressed through her sculpture are also present in her (largely unknown) works on paper, as in the series The Tower of Terror Studies (1994; fig. 15), in which she replaces original drawings with photocopies. Odenbach, a German artist of the same generation as Kippenberger and Noland, is best known for his politically charged video installations, in which he recombines feature films and archival footage. He began his career with large-scale works on paper, however, and he has also created ambitious, monumental collages that allude to rather than preach their political awareness.

Collage and assemblage have not entirely supplanted the more traditional forms of drawing, but they have expanded the perception of what a drawing can be, dramatically altering the notion of mark making and image making, of autographic and ideational procedures. When Harvey S. Shipley Miller began The Judith Rothschild Foundation Contemporary Drawings Collection in 2003, drawing had been the focus of artistic practice for several years, and Miller aimed to encompass the new territory that artists were staking out for it, by broadly extending the focus of both Rose's and Hoptman's seminal exhibitions into the present and by building on the historic connections between the different paths that those exhibitions expounded. It remains to be seen whether Miller's contemporary choices will have the same staying power as those made by Bernice Rose in 1976, or by Laura Hoptman

15
Cady Noland
American, born 1956
Untitled from *The Tower of Terror Studies*. 1994
Pencil on transparentized paper
14 1/8 × 16 7/8" (35.9 × 42.9 cm)

The Museum of Modern Art, New York. The Judith Rothschild Foundation Contemporary Drawings Collection Gift

half a decade ago. But there is no doubt that the collection is an extraordinary achievement in the ongoing evaluation of and dialogue about drawing, and it attests to the medium's continued vitality, its relevance for artists working today, and its contribution to the contemporary discourse about the role and use of images and their production, manipulation, and circulation. And with the holdings of the Contemporary Drawings Collection now part of the permanent collection of The Museum of Modern Art, we can evaluate its impact and importance for generations to come.

1 Bernice Rose, *Drawing Now* (New York: The Museum of Modern Art, 1976), p. 9.

2 Ibid.

3 Ibid., p. 14.

4 Ibid., p. 16.

5 Laura Hoptman, *Drawing Now: Eight Propositions* (New York: The Museum of Modern Art, 2002), p. 12.

6 Ibid., p. 167.

7 Ibid., p. 12.

8 A complete list of works in the collection can be found in *The Judith Rothschild Foundation Contemporary Drawings Collection Catalogue Raisonné* (New York: The Museum of Modern Art, 2009).

9 Hoptman, in an interview with Phyllis Tuchman, December 17, 2002, http://www.artnet.com/magazine/FEATURES/tuchman/tuchman12-17-02.asp.

10 Nicolas Bourriaud, *Postproduction: Culture as Screenplay: How Art Reprograms the World*, trans. Jeanine Herman (New York: Lukas & Sternberg, 2002). *Postproduction* is a continuation of *Relational Aesthetics* (trans. Simon Pleasance and Fronza Woods, with Mathieu Copeland; Dijon: Les presses du reel, 2002), Bourriaud's book on the early-1990s art practices concerned with social interaction and institutional interventions.

11 Bourriaud, *Postproduction*, p. 7.

12 "A drawing can be described," Rose writes, "as a structure in which lines and other kinds of marks are arranged in related groupings according to a master plan to which the whole arrangement is subordinate. In traditional drawing this relationship is hierarchical—characterized by a broad range of expressive devices variously subordinated to one another as well as to the motif. In recent drawings expression is dependent on a reduced and simplified range of marks, rearranged so that their relationship to one another becomes contingent, and their relationship to the rectangle of the sheet or the space allocated is the primary regulating device"; Rose, *Drawing Now*, p. 14.

13 Bourriaud, *Postproduction*, pp. 13–14.

Harvey S. Shipley Miller
and Gary Garrels
Interviewed by Cornelia Butler
and Christian Rattemeyer

*The Judith Rothschild Foundation Contemporary Drawings Collection,
a group of works assembled between 2003 and 2005, is an extraordinary
philanthropic undertaking. The collection was the brainchild of Harvey
S. Shipley Miller, the Trustee of The Judith Rothschild Foundation and
a member of the Committee on Drawings and the Board of The Museum
of Modern Art, New York. Miller, with The Judith Rothschild Foundation,
had previously undertaken a similar project, assembling one of the
finest collections of Russian avant-garde books in the world, which was
donated to the Department of Prints and Illustrated Books at MoMA in 2002.*

*The collection was conceived as a one-year project; it was eventually
extended by another year and expanded to include a panoramic
overview of the medium in all its material manifestations at that time.
It is contemporary in focus, and Miller amassed it with the intention
of donating it to an institution, preferably a New York museum. From the
start, Gary Garrels, then The Robert Lehman Foundation Chief Curator
of Drawings and Curator of Painting and Sculpture at The Museum
of Modern Art, and Director Glenn Lowry blessed the initiative, with the
hope that it would be offered to the Museum. André Schlechtriem, an
independent curator educated in Germany and based in New York, served
as the collection's consulting curator. In May 2005 the acquisition of
the collection, numbering around 2,500 works on paper, was proposed
to the Committee on Drawings at The Museum of Modern Art, which
unequivocally approved it.*

*In the following interview Miller and Garrels spoke with Cornelia
Butler, The Robert Lehman Foundation Chief Curator of Drawings, and me
about the genesis of and philosophy behind the collection.*
—Christian Rattemeyer

Cornelia Butler: Let's just start at the beginning. Was there a precise
starting point for The Judith Rothschild Foundation Contemporary
Drawings Collection?

Gary Garrels: I remember Harvey telling me about the concept
of the collection and asking me to review and approve it. We were
at The Museum of Modern Art's annual corporate luncheon for

the presentation of the David Rockefeller Award to Henry Paulson Jr., at the Metropolitan Club on March 11, 2003. Harvey came up to me after lunch and told me, "The next thing I'm going to do is to make a contemporary drawing collection, and I want to offer it to the Museum." And he said, "André and I went to the Armory Fair this weekend and it was like the scales fell from my eyes: I realized we're in an astonishing time for drawing, and there are so many artists making such amazing drawings." And he said—I do remember this so vividly—he said, "You know, I've been sitting on the drawing committee now for some time, but I really wasn't paying attention to contemporary drawings. And suddenly I realized, this is amazing what is going on. I've decided that what I would like to do next is to help form a contemporary drawing collection for the Museum." At this point the collection of Russian avant-garde books was touring and had recently opened at a venue in Europe. It was beginning to wind down and didn't need so much care and tending. Of course Harvey, not missing a beat, immediately decided to launch this new project. So that was the genesis of it. They had bought some drawings at the fair, and I said, "Well, I have a Rosemarie Trockel drawing on hold, so you should go take a look at that, and a couple of Lawrence Weiner drawings on hold, so you should go take a look at those." And that Friday, Harvey went down to Barbara Gladstone Gallery in Chelsea and bought four Trockel drawings and then went up to Marian Goodman Gallery and purchased two Weiner drawings and then some more things. I think that broke the whole thing wide open.

Harvey S. Shipley Miller: I had been buying a few little drawings for myself, with the idea that maybe I would offer some to the Museum. I hadn't realized that this was a very complex topic because these artists are not necessarily canonical figures like the artists of the Russian avant-garde. Once we started assembling the collection, we were looking at artists who were emerging, some going up and down. I was still an early modernist—that's where my focus lay—but I was fascinated. Laura Hoptman's *Drawing Now: Eight Propositions* had opened just a few months before and formed a background for what was happening right at that time. At the luncheon I asked Gary how he would feel about a collection of contemporary drawings offered to the Museum, and Gary said that it would be wonderful. Of course there was no obligation on the part of the Museum. I also spoke to Glenn [Lowry], as it was important to let him know about my plan right from the start. And he heartily endorsed it.

Christian Rattemeyer: And then the pace and the scale changed relatively quickly.

GG: Right from the beginning it was happening very quickly and at a scale that was beyond anything I ever could have imagined or

hoped for. When I first came to work at MoMA and surveyed the collection it was immediately apparent that there were gaps. And it would take years to remedy them in a museum functioning in a normal fashion. For instance, the Museum had a very nice collection of Trockel drawings from the 1980s and there might have been something from 1990 or 1991, but basically it was a group of 1980s works and then nothing. And drawings are very important for Trockel, so filling in these gaps absolutely made sense.

HSSM: I also have to say that the speed at which we assembled the collection is misleading. We worked with Gary, who has impeccable taste, and he had had works on hold for years, so it's a slight misconception to think we started from scratch and took only two years. When I went to L.A. for the first time, never having done the gallery scene there, I called Gary and he said, "Don't forget to go here and here, and see this and that." I don't remember one drawing he had liked that I didn't respect. I mean that. That was key for me, not coming from L.A. and not knowing the scene—it was really ten years of collecting that we were able to compress into a few short trips, in part because we had Gary's prior selection as a guide.

GG: But the other part of this is that Harvey's been a collector for decades, for himself and for institutions, through his many generous donations. First he assembled a print collection, beginning when he was just eleven years old, and then a photography collection from 1972 to 1989, a collection of Cubist prints by Jacques Villon, which was given to the Philadelphia Museum of Art, and then the Russian avant-garde collection, which went to MoMA. So Harvey comes with a very disciplined, trained, experienced eye, and he knows how to look at art and what kinds of questions to ask, a skill that takes years and years to develop. So I certainly knew the lay of the land in terms of the galleries of contemporary artists, and I had thoughts about what was needed for the collection. But then to work with someone like Harvey was extraordinary.

CR: Harvey, you told me that right around the same time you had bought a Chloe Piene drawing, which became one of the first drawings to enter the collection.

HSSM: Just before the Armory Show, I bought a drawing from her gallery. Gary had acquired one for the Museum that I thought was stunning. It reminded me of Egon Schiele and Joseph Beuys and Matthew Barney. I saw the agitation, the line, and I loved how she was using it. So that turned out to be the collection's first acquisition.

CR: What did you do then? Did you make a list of the ten, twenty, or hundred most important contemporary artists? Or did you let yourself be guided by what was out there?

GG: I was looking at the collection and identifying artists or periods where there were gaps. But André and Harvey very quickly realized that the art world appeared to be gravitating toward four major centers for contemporary art production: New York, Los Angeles, the United Kingdom—with London as the center, but also Glasgow—and then, of course, Germany, with Berlin as the anchor but also Cologne and Düsseldorf. So we were looking at the communities of artists in those cities and thinking about artists who were extremely well known but also those who were appreciated by other artists but maybe weren't as publicly recognized—emerging artists who were coming out of that activity, that dialogue, that discourse in those cities. That strategy of looking at the communities of artists city by city became a very strong guiding principle.

CR: You obviously traveled a lot. Did you go as far as Asia and Latin America?

HSSM: No. We went to all the major European and American art fairs for two years, as far east as Germany. Of course we went to Glasgow. But we did not go to Asia or to South America. We would see work by artists from those countries at the fairs.

GG: The real focus was on Berlin, Cologne, Düsseldorf, London, New York, L.A., and Glasgow. Harvey and André were incessantly in and out of galleries in those cities. Of course there were things from artists from Brazil or artists from Mexico or artists from Japan, but mainly at the fairs, where in one fell swoop you could see all the leading dealers from Europe in one place. The dealers still had material—the market wasn't yet so overheated that they were totally depleted. We never looked at the artists' origins. We looked at the art and its range of expression.

HSSM: We were just an inch ahead of the wave. I hired André to help find, select, and advise, and what's so interesting about this collection is that it's somewhat balanced between Europe and America, and very few collections formed here in America are. That was André's doing. Gary knew Europe, but André came from Cologne and studied there, he speaks German, and he had an awareness of the inner connections, the connective tissue of the emerging artists, and that's not something most American curators have. So we were privy to a lot of new people who weren't yet on everybody's radar screen. He also understood the sources of European narrative that were just reentering the field.

CB: I'm curious to know at which point you decided to add more historical material and an older generation of artists.

HSSM: We selected historical works based on how they informed what was happening today—works that were directly relevant to what we were seeing in the galleries, like the Henry Darger drawing. I felt there were a few artists without whom you couldn't really have a show of drawing as mark making, the masters of the medium. One was Cy Twombly, for me. Another was Beuys, and I knew that, although Bernice Rose and Ann Temkin did a very definitive Beuys show, in 1993, MoMA didn't have as strong a collection of his drawings as it should.

GG: Beuys is a good case in point: it became clear that there was so much work by contemporary German artists coming into the collection that we needed to include his work in more depth. He was lurking everywhere. It just so happened that some really wonderful Beuys drawings became available.

HSSM: Others were figurative works by Philip Guston and certainly Andy Warhol, but also outliers like Marcel Broodthaers and Öyvind Fahlström. And John Wesley opened his archive of 1960s drawings. Gary also arranged for us to visit Sherrie Levine.

GG: There was one small group of Sherrie Levine drawings in MoMA's collection. I think that, for Sherrie, works on paper are essential. So we went to her studio, and she started pulling out amazing things for us to see, and as a consequence we have an amazing core group of her work, including her last presidential collage (page 158). It was the only one she had left; she'd been holding on to it for herself. There was a similar situation with Cady Noland. We didn't have many drawings by Cady in the collection, and her works on paper are certainly very important to the way she works across mediums, incorporating sculptural materials, including paper clips and aluminum frames of her own design. I had known Cady for a long time, but Jordan Kantor, at the time an assistant curator in the Department of Drawings, also had a great relationship with her, and Harvey arranged for us to see a definitive selection of drawings through the gallerist Andrew Leslie. We went down to her studio, and we made a selection of works. Another very important artist would be Ray Johnson. We had only two works on paper in the collection, one from 1959 and one from 1967. And Harvey fell in love with the work.

HSSM: Oh, I was just besotted. And now the range of his entire oeuvre is represented in the Museum's collection, starting in the 1950s with *Untitled (Moticos with Everly Brothers)* (page 306), which he began in 1953, and ending with *Untitled (Ray Johnson Collages One Million*

Dollars Each), from 1993–94. Another person whose work I fell in love with was Bruce Conner.

GG: There were certain artists who were underrecognized, both art historically and by the market, so that there were still great bodies of work available. Bruce had been working in drawings since the early 1960s. So there was this amazing opportunity, and the same with John Wesley, whose drawings had never been much on the market. And so those artists ended up having very large groups of works in the collection. And we never stopped.

CR: Am I right in thinking that your collecting activities coincided with an industry-wide refocus on some of these forgotten figures? For instance, Lee Bontecou, in that touring retrospective.

GG: I think we were in a moment when there were a number of figures who had been very important in the 1960s and who had not been given their due—art history hadn't really caught up with their importance. For some of these artists, works on paper were fundamental. Bontecou is an amazing sculptor, but drawings are essential to her work. The particular story on Bontecou was the opening of her retrospective at the Hammer Museum, in October 2003. Interest had been building, and we felt it was the last moment to have access to the really important works. So Harvey, André, and I all went out for the opening. We were literally the first people at the door to walk into the gallery.

HSSM: So we looked at the labels, we looked at the show and ran through—

GG: —with our little pads, writing notes.

HSSM: The ur-drawing was that untitled soot drawing from 1958 (page 300). There were others interested in buying the work, but Lee did not want to part with it. In the end, we acquired it. She knew about the project, and she saw the authenticity of our reaction. You know, mission first, dignity second, but only for an institution, never for myself.

GG: There were other museum shows. For instance, there was a Lucas Samaras show at the Whitney. I think that show was a real eye-opener, showing how important drawing had been for Lucas and how much drawing he had done. It was all laid out there before us. We went a few times to see the exhibition, and we began to think about a core group of Lucas's drawings that might come to the collection. And I have to say that because people knew that this collection was going to be offered to MoMA, artists did agree to part with things that they wouldn't have parted with under other circumstances.

HSSM: Lucas did not want to let go of his transcendentally beautiful and brilliant skull drawing. However—as I often say—"No is but a way station to yes." He ultimately agreed to let it go.

CB: So when did the idea occur of a panorama of drawings, of a widely cast look at drawing practices today?

GG: Our ambition for the collection fairly quickly became the representation of drawing at this moment in history—identifying those four centers where contemporary artists were working, and focusing particularly on artists there. Burrowing down deeper and trying to understand what was going on in a more specific way in those places and in the relationships between artists.

CB: There has been a real emergence of drawing in the last ten years or so, which is the point that Laura Hoptman's exhibition made.

GG: It was very important in the 1960s. And then it did seem like it was kind of submerged or it just wasn't being paid attention to, and then at some point in the 1990s it began to reemerge.

HSSM: But why did drawing take a position pari passu with other art forms? I think it has to do with the protean nature of today's artists, that they're not simply painters or sculptors or filmmakers. They're working with many different mediums. And drawing could find a very happy place that was of equal weight with other things they were doing.

GG: There has also been an emergence of an intense use of imagery, of narrative, of the diaristic and the fantastic in drawing. We were talking about Laura Hoptman's exhibition, which she saw as the foil to Bernice Rose's 1976 *Drawing Now*—the way that drawing in the 1990s was going back to the nineteenth century and reengaging history and fantasy and illustration and decoration, in a 180-degree turn from what had been done in the 1960s. Drawing was at the center of this new production. And there were certain artists whose primary medium was drawing, like Raymond Pettibon or Mike Kelley—for them drawing is a bedrock for their production. And many artists were realizing that you couldn't understand what was going on in the field of contemporary art without paying attention to recent drawing practices.

CR: I am interested in how the collection changed the idea of what a MoMA work is—maybe not what a MoMA work was in 1932, but what a MoMA work was in 2000.

GG: The more I dug into the history of MoMA, the more I realized that MoMA in its earlier years, in the 1930s and '40s particularly, had been

a very adventuresome, risk-taking institution. [Museum founding director] Alfred Barr, Jr., was absolutely the leader of that. So the definition of MoMA in that period was very different from the definition of MoMA in the last thirty years. Barr was also a champion of outsider art, which he saw as relevant to contemporary art at the time, with *l'art brut* and so on. Some time ago, Margit Rowell acquired Bill Traylor drawings for the Museum, and later organized an exhibition on Antonin Artaud, so it wasn't like this was completely a lost part of the Museum's history. We just tried to reengage it in a more vigorous way.

HSSM: It also was very important to me that this collection not overlook other artists toiling in the vineyard, so to speak, who may not yet be recognized as masters but who have a position of influence on other artists and are part of the richness of the landscape. Take, for instance, Graham Nickson. His work is in the collection of The Metropolitan Museum of Art. He has had a huge influence as a teacher and is a very accomplished draftsman, but maybe he would not have been sought out by MoMA because he might have been deemed too conservative.

CB: So part of the panorama concept is this notion of the underrecognized artist. If you're really going to make a full picture of a moment, you have to include them. But I do think it's worth restating that it is also a radical thing for this institution, and one that goes back to an earlier moment in its history.

CR: What was the reaction of MoMA's acquisition committee when you presented the collection?

HSSM: Gary presented the collection in hierarchical categories: more familiar, less familiar, emerging artists, and the wild cards. And I thought that was very fair because people felt comfortable with that kind of division. But the collection was, for a while, so controversial—shall I say radioactive?—that it's wonderful to see how it has settled into the life of the Museum.

GG: There's no question that it was controversial, and there were two primary arguments about it. One was that the collection hadn't been formed by curatorial decision, and this came up because people hadn't understood the extent to which I was involved in the decision making. And the other was whether MoMA should be a collection only of great, singular masterpieces or a collection that was also about other kinds of issues in art making—about discourse among artists or about the texture or range of what's being made at a particular time, so that artists who may not end up as canonical figures still have an interesting place in the history of art. Certainly we wanted to find canonical masterpieces, and I think we did. But we were working with the idea

that drawing is something closely related to an artist's thinking and process and development; it isn't just the singular distillation, where all the lessons have been learned and brought into complete focus in one finished work. So bringing this collection forward created a kind of philosophical tension. But as people began to see its extraordinary treasures, the excitement began to build, and gradually we turned the corner. By the time the collection came up for a formal vote, the committee voted unanimously and with tremendous enthusiasm to acquire it. There was tremendous leadership—Glenn Lowry and Kathy Fuld, who is the chairman of the Committee on Drawings, were both extremely supportive. And it's been incredibly gratifying to me to see the works incorporated into the Museum's collection, in the rotations of the permanent galleries. I think people have now recognized what an extraordinary richness this collection has brought to the Museum.

CR: There can't be a bigger compliment to the collection than the fact that it is now fully integrated into the holdings of the Museum.

CB: You both talked about how this was going to transform the Museum's collection. The shift that has taken place is absolutely extraordinary—a full one-third of the drawings collection is now solidly from the contemporary period, and many of those artists are new to the collection.

GG: That was very much part of the plan. I think once you understand both the strategic and the serendipitous art of the collection, there is a form to it that maybe isn't instantly obvious when you just read through a checklist.

HSSM: I think we engendered a lot of goodwill. The Museum actually sent membership cards to every single artist in the collection. Do you know how many artists have said to me, "Oh, I'm so glad to have that card"?

CR: There is quite a range of scale of the works in the collection, from Tom Friedman's fly to Angus Fairhurst's billboards (e.g., page 46). Were you aware of looking for work of a particular scale?

GG: We never thought about it. The idea was that the collection should represent the full range of drawing's capacity as a medium.

HSSM: Look at the two drawings by Neo Rauch (e.g., page 271). Those are great drawings of their moment. They're big, but so what? In fact, that added a certain power—that drawing was asserting itself as equal to other forms: "We're not afraid to go to your size, and we're not afraid to be as intimate and small as we used to be."

GG: The same holds true of Paul McCarthy's *Penis Hat* (page 283), from 2001, surely a monumental drawing in terms of scale. But we also felt it was an absolutely necessary addition to the collection. If you're going to represent drawing being done in Los Angeles, Paul is absolutely a foundation, a touchstone. This was a situation where the dealer called Harvey because they knew about the collection and said this drawing is available, and it couldn't be more perfect.

HSSM: And it's a great drawing—not a quiet drawing, but a master drawing. McCarthy considers it among his greatest works.

GG: I knew McCarthy's work very well, and I know that its subject matter can be quite challenging. When I went down to see the drawing, I wondered how I was going to present it at the Museum. I have to say it really gave me pause. But there was a lot of sexual imagery in many of the other works we were acquiring, and sexuality is a central issue to many contemporary artists. So we felt this vein of work absolutely had to be represented in the collection. You couldn't draw arbitrary boundaries around subject matter and not include it.

CR: You mentioned that the inclusion of outsider artists was an outgrowth or development of your looking at the work of younger artists, different from your decision to include Twombly, Beuys, and Johns, for example. Can you chart that course—how you went from young to old and from young to outsider and whether you feel the conversations with the emerging artists led to a filling-in of the other works?

HSSM: I grew up in Philadelphia and collected outsider art a little bit, because one of the great galleries there was the Janet Fleischer Gallery (now Fleisher/Ollman Gallery). Outsider art for me was simply art, and so there was no division in my mind. So when we saw works by outsider artists that were resonant, it just seemed absolutely logical to include them.

GG: The initial intent was a collection of contemporary drawings. But as the collection developed, we came to the recognition that you couldn't have a contemporary drawing collection with some of the key figures missing. Like Beuys, but also other historic figures.

HSSM: Beuys, for me, was tough to understand, so I'd ask question after question. The gallerist Michael Werner was very helpful, and from him I learned more about Jörg Immendorff, Per Kirkeby, Georg Baselitz, and so on. Sigmar Polke was important to us. I'd always thought Gerhard Richter was the more important artist—that was the name I had heard. But if you ask any thoughtful curator, they'll say Polke.

His work was so compelling; he is an artist of greatness, and so many people have flowed from him. But I also discovered other artists from the 1960s. One day André said we should go to Dia:Beacon. There were three artists on exhibit there whose work I did not previously know, and they changed my life, my vision: Fred Sandback, Hanne Darboven, and—my favorite—Blinky Palermo. I became a Blinky Palermo insane person!

GG: The Museum had previously acquired excellent examples of Polke drawings from the 1960s but had only a few works subsequent to that and no recent work at all. So what the Rothschild collection was bringing in was a wonderful sweep of more recent work from the last few years, complementing the holdings already in the Museum's collection with new work just out of the studio.

CR: There's a group of works in the collection that are partially credited to The Michael and Eileen Cohen Collection. It mainly contains works from the 1960s and 1970s and fills in particular gaps in the collection.

HSSM: Eileen and Michael Cohen are pioneering art collectors with a great eye. A number of works from the 1960s and early 1970s from their collection were on exhibit at Zwirner & Wirth and were for sale, and I went to see the show. By chance, Gary, André, and I all went independently. I thought before seeing them, "Oh, maybe we should just buy a few of these," but in the end we decided to keep the group intact.

GG: I knew the work from what the Cohens have hanging in their loft downtown. I'd seen a lot of it, but I'd never seen it all together as a collection. And I was flabbergasted. I was stunned by the quality of the work and what it represented: works that would have been very difficult to find at that point. The Cohens took years assembling their collection. So this was one of those situations where a foundation for the collection could be established in one fell swoop.

CR: Were there moments when you felt constrained because of the decision to offer the collection to the Museum?

GG: Harvey knew that we weren't going to make all the right decisions all the time. He said, "I want to offer this collection to the Museum, but I'm not going to put any restraints on it. Over time, if the Museum wants to deaccession something, that's going to be for the next generation to figure out." This made me feel more comfortable as a curator with a responsibility to an institution—to know that we would take risks and that it wasn't going to be a perfectly formed collection. But it didn't feel like we were closing the door to the Museum but rather opening doors to the future. That was part of my thinking: that this collection would give the Museum the groundwork for building

41

a great contemporary collection. Inevitably it would have its own particular contours, but it would then be a jumping-off point to do many, many, many other things down the road. It was exactly what I had hoped for when I started at MoMA: the opportunity to build a postwar collection in a way that would have weight and quality and character commensurate with the holdings of works from the modern period.

CR: When did you feel that the collection was complete?

HSSM: It was supposed to be a one-year project. Then it got extended to two years. We had to set a limit because otherwise there would be no end to it. And the idea was that the collection would be a cross-section of a moment in time. We were a bit evangelical; we wanted this thing we all loved to have a public presence, and in tandem with that we hoped that artists would feel like the Museum was a place that was really reaching out to engage them in a vital, active kind of way. The relationships that developed through the collection—whether with dealers or artists—became fundamental to what we were able to accomplish.

Plates

Angus Fairhurst
British, 1966–2008
Four billboards, body and text removed. 2003
Cut-and-pasted printed paper on paper
11' ¼" × 19' 8 ¼" (335.9 × 600.1 cm)

Eva Rothschild
British, born Ireland 1972
Absolute Power. 2001
Cut-and-woven printed paper
9' 11" × 7' (302.3 × 213.4 cm)

Cy Twombly
American, born 1928
Untitled. 2001
Synthetic polymer paint, crayon,
and cut-and-pasted paper on paper
48 ½ × 38 ¾" (123.2 × 98.4 cm)

The Judith Rothschild Foundation Contemporary
Drawings Collection Gift. Given in honor of
Kathy Fuld

André Thomkins
Swiss, 1930–1985
Untitled. 1965
Lackskin (enamel) on paper
6' 5 ¼" × 9' 2 ½" (196.2 × 280.7 cm)

Jasper Johns
American, born 1930
From Juan Gris. 2000
Ink on transparentized paper
26 ³/₄ × 21 ³/₈" (67.9 × 54.3 cm)

From Juan Gris. 2000
Ink on transparentized paper
27 ⁵⁄₈ × 21 ⁵⁄₈" (70.2 × 54.9 cm)

Nick Mauss
American, born 1980
Untitled. 2003
Synthetic polymer paint on printed paper
11 × 8 ½" (27.9 × 21.6 cm)

Untitled. 2003
Oil, felt-tip pen, and cut-and-pasted
printed paper on paper
11 ³/₈ × 8 ½" (28.9 × 21.6 cm)

Untitled. 2003
Synthetic polymer paint, felt-tip pen,
and carbon paper transfer on paper
22 ¹/₂ × 16 ⁵/₈" (57.2 × 42.2 cm)

Untitled. 2003
Synthetic polymer paint, pencil, carbon
paper transfer, felt-tip pen, ink, and
crayon on paper
20 × 15 ³/₈" (50.8 × 39.1 cm)

David Hammons
American, born 1943
TOP: *Untitled / Green Power*. 1975
Pigment on paper
14 ³⁄₄ × 17 ³⁄₄" (37.5 × 45.1 cm)

BOTTOM: *Body Print*. 1975
Pigment on paper
23 ¹⁄₄ × 29 ¹⁄₈" (59.1 × 74 cm)

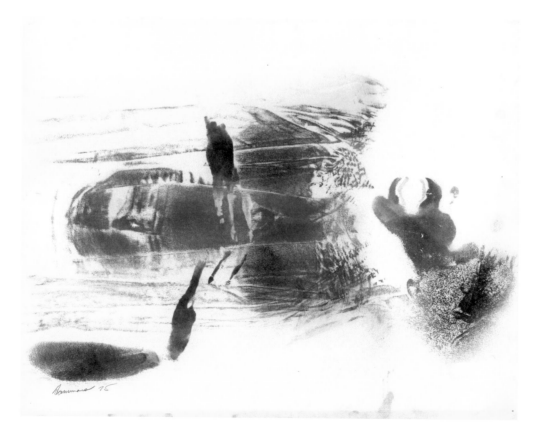

Chloe Piene
American, born 1972
Thirty Years Old. 2002
Charcoal on transparentized paper
46 × 30" (116.8 × 76.2 cm)

Robert Rauschenberg
American, 1925–2008
Untitled. 1974
Pencil and synthetic polymer paint with
packing tape and mailing labels on paper
36 ½ × 23 ½" (92.7 × 59.7 cm)

The Judith Rothschild Foundation Contemporary
Drawings Collection Gift (purchase, and gift, in part,
of The Eileen and Michael Cohen Collection)

Joseph Beuys
German, 1921–1986
Aktionsplan (Action Plan). 1964
Pencil and stamped ink on two
pieces of paper
Each 11 ¾ × 8 ⅛" (29.8 × 20.6 cm)

Untitled. 1956
Pencil on graph paper
5 ¾ × 4" (14.6 × 10.2 cm)

Kräfte (Forces). 1973
Pencil on two pieces of paper on paperboard
35 ½ × 26 ⅞" (90.2 × 68.3 cm)

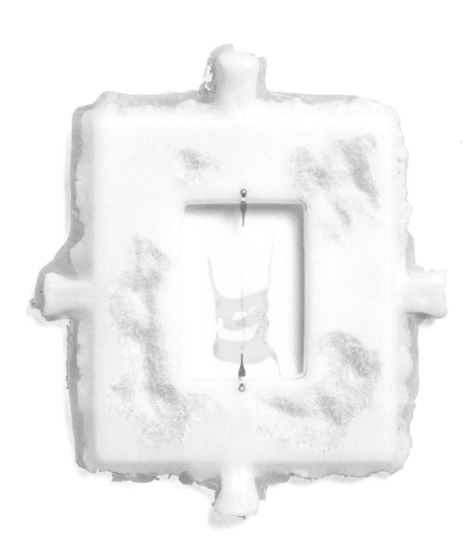

Matthew Barney
American, born 1967
Ursula. 2003
Pencil, watercolor, and petroleum jelly
on three pieces of paper in rotomolded
polyethylene frames with nylon fiber
LEFT TO RIGHT: 15 × 13 × 1 ¼"
(38.1 × 33 × 3.2 cm), 12 ⅞ × 14 ¾ × 1 ¼"
(32.7 × 37.5 × 3.2 cm), 14 ½ × 13 × 1 ¼"
(36.8 × 33 × 3.2 cm)

Miroslaw Balka
Polish, born 1958
Untitled. 1985/1990
LEFT TO RIGHT: ink on burned paper,
6 1/2 × 3 1/8" (16.5 × 7.9 cm); ballpoint pen
and felt-tip pen on burned graph paper,
8 × 4 7/8" (20.3 × 12.4 cm); felt-tip pen
on burned printed paper, 4 1/4 × 3 3/4"
(10.8 × 9.5 cm); felt-tip pen and pencil
on burned paper, 7 3/4 × 6" (19.7 × 15.2 cm);
felt-tip pen on burned paper, 7 × 5 3/4"
(17.8 × 14.6 cm)

Dan Flavin
American, 1933–1996
TOP: *the diagonal of May 25, 1963.* 1964
Colored pencil on black paper
9 7⁄8 × 12 7⁄8" (25.1 × 32.7 cm)

BOTTOM: *proposition two of May 15, 1964.* 1965
Colored pencil on paper
12 3⁄4 × 19 3⁄4" (32.4 × 50.2 cm)

Donald Judd
American, 1928–1994
Untitled. 1970
Felt-tip pen on colored paper
17 1/8 × 22" (43.5 × 55.9 cm)

The Judith Rothschild Foundation Contemporary
Drawings Collection Gift (purchase, and gift, in part,
of The Eileen and Michael Cohen Collection)

Fred Sandback
American, 1943–2003
Installation Drawing from Dwan Gallery. 1969
Felt-tip pen and pencil on printed paper
16 ½ × 21 ⅞" (41.9 × 55.6 cm)

The Judith Rothschild Foundation Contemporary
Drawings Collection Gift (purchase, and gift, in part,
of The Eileen and Michael Cohen Collection)

FRED SANDBACK APRIL 4-30 DWAN GALLERY 29 WEST 57 NEW YORK

Adrian Piper
American, born 1948
Drawings about Paper #46. 1967
Cut-and-pasted colored paper and pencil on
notebook paper in synthetic polymer sleeve
11 × 8 ½" (27.9 × 21.6 cm)

The Judith Rothschild Foundation Contemporary
Drawings Collection Gift (purchase, and gift, in part,
of The Eileen and Michael Cohen Collection)

Drawings about Paper #47. 1967
Pencil on notebook paper in synthetic
polymer sleeve
11 × 8 ½" (27.9 × 21.6 cm)

The Judith Rothschild Foundation Contemporary
Drawings Collection Gift (purchase, and gift, in part,
of The Eileen and Michael Cohen Collection)

Drawings about Paper #48. 1967
Pencil on paper in synthetic
polymer sleeve
11 × 8 ½" (27.9 × 21.6 cm)

The Judith Rothschild Foundation Contemporary
Drawings Collection Gift (purchase, and gift, in part,
of The Eileen and Michael Cohen Collection)

Richard Tuttle
American, born 1941
Untitled. 1965
Gouache and pencil on notebook paper
14 × 16 ¾" (35.6 × 42.5 cm)

The Judith Rothschild Foundation Contemporary
Drawings Collection Gift (purchase, and gift, in part,
of The Eileen and Michael Cohen Collection)

Jo Baer
American, born 1929
Sex Symbol. 1961
Gouache and pencil on paper
6 × 3 ¼" (15.3 × 8.3 cm)

The Judith Rothschild Foundation Contemporary
Drawings Collection Gift (purchase, and gift, in part,
of The Eileen and Michael Cohen Collection)

Untitled. 1963
Felt-tip pen, colored pencil, and
pencil on paper
5 ½ × 7" (14 × 17.8 cm)

The Judith Rothschild Foundation Contemporary
Drawings Collection Gift (purchase, and gift, in part,
of The Eileen and Michael Cohen Collection)

Entwurf für Graphik zur Wandmalerei,
Bremerhaven (Study for Print for
Wall Painting, Bremerhaven). 1971
Gouache, pencil, and ballpoint pen on paper
34 × 23 ¾" (86.4 × 60.3 cm)

Agnes Martin
American, born Canada. 1912–2004
Untitled. 1978
Watercolor and colored ink
on transparentized paper
9 × 9" (22.9 × 22.9 cm)

Bridget Riley
British, born 1931
Untitled. 1972
Gouache and pencil on graph paper
12 ¼ × 11" (31.1 × 27.9 cm)

The Judith Rothschild Foundation Contemporary
Drawings Collection Gift (purchase, and gift, in part,
of The Eileen and Michael Cohen Collection)

Robert Mangold
American, born 1937
*Four Distorted Rectangles with Line Division
(Green, Blue, Sand, Ocher).* 1979
Synthetic polymer paint and pencil
on four pieces of paper
Each 39 × 27 ½" (99.1 × 69.9 cm)

The Judith Rothschild Foundation Contemporary
Drawings Collection Gift. Given in honor of
Mrs. June Noble Larkin

Ellsworth Kelly
American, born 1923
Study for *Painting in Eighteen Panels*. 1978
Cut-and-pasted colored paper and
pencil on paper
18" × 10' 9 ³/₄" (45.7 × 329.6 cm)

Brice Marden
American, born 1938
Suicide Notes. February 1972–July 1973
Sketchbook with twenty-eight ink drawings
Each page 12 ¼ × 8 ½" (31.1 × 21.6 cm)

Yayoi Kusama
Japanese, born 1929
Airmail No. 2 Accumulation. 1963
Airmail labels on paper
9 ⅛ × 10 ½" (23.2 × 26.7 cm)

The Judith Rothschild Foundation Contemporary
Drawings Collection Gift (purchase, and gift, in part,
of The Eileen and Michael Cohen Collection)

Carl Andre
American, born 1935
words men word court proofs years
hair men cell. 1962
Typed carbon paper transfer on paper
11 × 8 ½" (27.9 × 21.6 cm)

The Judith Rothschild Foundation Contemporary
Drawings Collection Gift (purchase, and gift, in part,
of The Eileen and Michael Cohen Collection)

```
words men word court proofs years hair men cell
crimes man code court courts skies hell men met
court men mind blood courts peace life men code
term men time voice slaves heart page men court
lot men case court youths deeds life men clique
case men word court school shame hell men words
court men oath court things world soul men name
crimes men jail court slaves blood soul men men
hands men code roles speech blood lips way time
head men case ghost crimes youth site war homes
way men code voice rights truth word war knives
mood way code court waists court home men books
books men arms heart stones court loaf man life
ground men gang world search court task men men
court men life right shacks truth fate man days
time men boys years months group arms men years
men men fact court plague death road men school
hand men girl times source blade camp men years
truth men gate lines courts voice pool men time
courts men word lines health night hour day man
slave men fact right threat facts head cog camp
time kin camp truth cheese court head men crime
kin end hand field source truth arms men skills
hand men fort years months crime eyes man years
years car boys truth mouths shame boys law arms
wretch men fate voice throne blood cell man men
```

```
JULY26MOVEMENTCUBA SIDE2
```

John Cage
American, 1912–1992
Untitled (640 numbers between 1 and 21). 1969
Ballpoint pen, pencil, colored pencil,
and felt-tip pen on printed paper
11 × 8 ½" (27.9 × 21.6 cm)

The Judith Rothschild Foundation Contemporary
Drawings Collection Gift (purchase, and gift, in part,
of The Eileen and Michael Cohen Collection)

Untitled (640 numbers between 1 and 16). 1969
Ballpoint pen, pencil, and colored pencil
on printed paper
11 × 8 ½" (27.9 × 21.6 cm)

The Judith Rothschild Foundation Contemporary
Drawings Collection Gift (purchase, and gift, in part,
of The Eileen and Michael Cohen Collection)

Merce Cunningham
American, born 1919
*Suite by Chance (Space Chart Entrance
and Exit).* 1952
Ballpoint pen and pencil on colored
graph paper
7 × 7" (17.8 × 17.8 cm)

The Judith Rothschild Foundation Contemporary
Drawings Collection Gift (purchase, and gift, in part,
of The Eileen and Michael Cohen Collection)

Barry Le Va
American, born 1941
*Diagram for Two Separate Installations
Combined into One Installation in
2 Perspectives.* 1982
Charcoal, synthetic polymer paint, pastel,
ink, and cut-and-pasted transparentized
paper on paper
47 × 48" (119.4 × 121.9 cm)

87

Robert Watts
American, 1923–1988
Untitled (from the series "Tree Wind Paintings"). 1983–84
Felt-tip pen on printed paper
24 × 14" (61 × 35.6 cm)

Lawrence Weiner
American, born 1942
Untitled. 1968
Ink on graph paper
11 × 8 ½" (27.9 × 21.6 cm)

The Judith Rothschild Foundation Contemporary
Drawings Collection Gift (purchase, and gift, in part,
of The Eileen and Michael Cohen Collection)

Douglas Huebler
American, 1924–1997
Variable Piece #70: Global 81. 1973
Synthetic polymer paint on cut-and-
pasted paper on gelatin silver print,
typewriting and pencil on printed paper,
and pressure-sensitive stickers on
gelatin silver print, all mounted in mat
48 × 45" (121.9 × 114.3 cm)

Lawrence Weiner
American, born 1942
Movement without Visible Vector. 1991
Watercolor, ink, and pencil on four
pieces of paper
Each 19 × 23 ⅞" (48.3 × 60.6 cm)

Robert Barry
American, born 1936
30 Pieces (Something which is very near in place and time but not yet known to me). 1969–71
Typewriting on five pieces of paper
Each 11 × 8 ½" (27.9 × 21.6 cm)

ROBERT BARRY

SOMETHING WHICH IS VERY NEAR IN PLACE AND TIME, BUT NOT YET KNOWN TO ME. 2 AUG. 1969.

SOMETHING WHICH IS VERY NEAR IN PLACE AND TIME, BUT NOT YET KNOWN TO ME. 7 JULY 1970.

SOMETHING WHICH IS VERY NEAR IN PLACE AND TIME, BUT NOT YET KNOWN TO ME. 27 SEPT. 1970.

SOMETHING WHICH IS VERY NEAR IN PLACE AND TIME, BUT NOT YET KNOWN TO ME. 11 OCT. 1970.

SOMETHING WHICH IS VERY NEAR IN PLACE AND TIME, BUT NOT YET KNOWN TO ME. 15 NOV. 1970.

2.

ROBERT BARRY

SOMETHING WHICH IS VERY NEAR IN PLACE AND TIME, BUT NOT YET KNOWN TO ME. 9 JAN. 1971.

SOMETHING WHICH IS VERY NEAR IN PLACE AND TIME, BUT NOT YET KNOWN TO ME. 24 JAN. 1971.

SOMETHING WHICH IS VERY NEAR IN PLACE AND TIME, BUT NOT YET KNOWN TO ME. 6 FEB. 1971.

SOMETHING WHICH IS VERY NEAR IN PLACE AND TIME, BUT NOT YET KNOWN TO ME. 11 FEB. 1971.

SOMETHING WHICH IS VERY NEAR IN PLACE AND TIME, BUT NOT YET KNOWN TO ME. 15 FEB. 1971.

SOMETHING WHICH IS VERY NEAR IN PLACE AND TIME, BUT NOT YET KNOWN TO ME. 19 FEB. 1971.

SOMETHING WHICH IS VERY NEAR IN PLACE AND TIME, BUT NOT YET KNOWN TO ME. 19 FEB. 1971.

3.

ROBERT BARRY

SOMETHING WHICH IS VERY NEAR IN PLACE AND TIME, BUT NOT YET KNOWN TO ME. 1 MAR. 1971.

SOMETHING WHICH IS VERY NEAR IN PLACE AND TIME, BUT NOT YET KNOWN TO ME. 1 MAR. 1971.

SOMETHING WHICH IS VERY NEAR IN PLACE AND TIME, BUT NOT YET KNOWN TO ME. 4 MAR. 1971.

SOMETHING WHICH IS VERY NEAR IN PLACE AND TIME, BUT NOT YET KNOWN TO ME. 4 MAR. 1971.

SOMETHING WHICH IS VERY NEAR IN PLACE AND TIME, BUT NOT YET KNOWN TO ME. 4 MAR. 1971.

SOMETHING WHICH IS VERY NEAR IN PLACE AND TIME, BUT NOT YET KNOWN TO ME. 4 MAR. 1971.

4.

ROBERT BARRY

SOMETHING WHICH IS VERY NEAR IN PLACE AND TIME, BUT NOT YET KNOWN TO ME. 4 MAR. 1971.

SOMETHING WHICH IS VERY NEAR IN PLACE AND TIME, BUT NOT YET KNOWN TO ME. 4 MAR. 1971.

SOMETHING WHICH IS VERY NEAR IN PLACE AND TIME, BUT NOT YET KNOWN TO ME. 4 MAR. 1971.

SOMETHING WHICH IS VERY NEAR IN PLACE AND TIME, BUT NOT YET KNOWN TO ME. 31 MAR. 1971.

SOMETHING WHICH IS VERY NEAR IN PLACE AND TIME, BUT NOT YET KNOWN TO ME. 27 APR. 1971.

SOMETHING WHICH IS VERY NEAR IN PLACE AND TIME, BUT NOT YET KNOWN TO ME. 11 MAY 1971.

SOMETHING WHICH IS VERY NEAR IN PLACE AND TIME, BUT NOT YET KNOWN TO ME. 17 MAY 1971.

SOMETHING WHICH IS VERY NEAR IN PLACE AND TIME, BUT NOT YET KNOWN TO ME. 31 MAY 1971.

5.

ROBERT BARRY

SOMETHING WHICH IS VERY NEAR IN PLACE AND TIME, BUT NOT YET KNOWN TO ME. 1 JUNE 1971.

SOMETHING WHICH IS VERY NEAR IN PLACE AND TIME, BUT NOT YET KNOWN TO ME. 7 JUNE 1971.

SOMETHING WHICH IS VERY NEAR IN PLACE AND TIME, BUT NOT YET KNOWN TO ME. 14 JUNE 1971.

On Kawara

Japanese, born 1933

I AM STILL ALIVE. 1973

Ballpoint pen on four telegrams

Each 5 ⅞ × 8 ¼" (14.9 × 21 cm)

The Judith Rothschild Foundation Contemporary

Drawings Collection Gift (purchase, and gift, in part,

of The Eileen and Michael Cohen Collection)

Mark Lombardi

American, 1951–2000

Gerry Bull, Space Research Corporation and Armscor of Pretoria, South Africa, c. 1972–80 (5th Version). 1999

Pencil and colored pencil on paper

58 ½ × 71 ¾" (148.6 × 182.2 cm)

Gabriel Orozco
Mexican, born 1962
Untitled. 2002
Gouache on printed paper
12 ½ × 9 ½" (31.8 × 24.1 cm)

Hanne Darboven
German, born 1941
Month III (March). 1974
Ink on thirty-one pieces of
transparentized paper
Each 11 ½ × 8 ¼" (29.2 × 21 cm)

97

Öyvind Fahlström
Swedish, born Brazil. 1928–1976
Sketch for World Map. 1972
Ink on paper
19 × 37" (48.3 × 94 cm)

Sol LeWitt
American, 1928–2007
*A Photograph of Mid-Manhattan with the
Area between The Plaza, Ansonia, Biltmore
and Carlyle Hotels Removed (R 770).* 1978
Cut gelatin silver print
15 ⁷⁄₈ × 15 ⁷⁄₈" (40.3 × 40.3 cm)

The Judith Rothschild Foundation Contemporary
Drawings Collection Gift (purchase, and gift, in part,
of The Eileen and Michael Cohen Collection)

John Baldessari
American, born 1931
*Junction Series: Landscape, Seascape,
Bodybuilders (One Flexing for Admirer).* 2002
Cut-and-taped printed paper with crayon
and pencil on graph paper
17 7/8 × 17" (45.4 × 43.2 cm)

Gordon Matta-Clark
American, 1945–1978
Energy Tree. 1972–73
Felt-tip pen, crayon, and pencil on paper
22 ½ × 28 ½" (57.2 × 72.4 cm)

Paul Thek
American, 1933–1988
TOP: *Hot Potatoes*. 1974
Synthetic polymer paint and ink
on notebook paper
9 ³⁄₈ × 13" (23.8 × 33 cm)

BOTTOM: *3 Prunes*. 1975
Synthetic polymer paint and
pastel on newspaper
22 ¹⁄₂ × 33 ¹⁄₄" (57.2 × 84.5 cm)

The Judith Rothschild Foundation Contemporary
Drawings Collection Gift (purchase, and gift, in part,
of The Eileen and Michael Cohen Collection)

103

Jack Smith
American, 1932–1989
Evil of the Brassiere World. 1969
Unbound book with ink on thirty-one
printed pages
Each page 11 ¼ × 8 ¾" (28.6 × 22.2 cm)

Lee Lozano
American, 1930–1999
TOP: *Untitled (Tool)*. c. 1963
Pencil and crayon on paper
23 × 29" (58.4 × 73.7 cm)

BOTTOM: *Untitled (Tool)*. c. 1964
Pencil and crayon on paper
10 × 29" (25.4 × 73.7 cm)

105

Jackie Ferrara

American, born 1929

(D20) Concave Curved Pyramid

(A and B) 1–76. 1976

Ink, pencil, colored pencil, and felt-tip

pen on graph paper

22 ¼ × 17 ⅝" (56.5 × 44.8 cm)

The Judith Rothschild Foundation Contemporary
Drawings Collection Gift (purchase, and gift, in part,
of The Eileen and Michael Cohen Collection)

Tom Levine
American, born 1945
12.XII.03. 2003
Oil pastel, charcoal, and pencil on paper
16 $\frac{5}{8}$ × 19 $\frac{1}{4}$" (41.6 × 48.9 cm)

Eva Hesse
American, born Germany. 1936–1970
No title. c. 1963
Gouache, ink, felt-tip pen, crayon, pencil,
and cut-and-pasted painted paper on paper
19 ⅝ × 25 ½" (49.8 × 64.8 cm)

Ree Morton
American, 1936–1977
Weeds of the Northeast #5. 1974
Watercolor, crayon, pencil, and colored
pencil with glitter on printed paper
18 ⁷⁄₈ × 24 ⁷⁄₈" (47.9 × 63.2 cm)

Intra-Venus Hand No. 9
October 1991. 1991
Gouache and watercolor on
notebook paper
12 ½ × 9 ½" (31.8 × 24.1 cm)

Lucas Samaras
American, born Greece 1936
Large Drawing #45. 1966
Colored pencil and pencil on paper
17 × 14" (43.2 × 35.6 cm)

Head #12. 1981
Pastel on black paper
17 ³⁄₄ × 11 ¹⁄₂" (45.1 × 29.2 cm)

John Wesley
American, born 1928
U.S. Army Recruiting Poster, 1970
Pencil on transparentized paper with
masking tape on paper
15 × 16 ¾" (38.1 × 42.5 cm)

Bruce Nauman
American, born 1941
Untitled. 1994
Pencil on cut-and-pasted printed paper
32 ⁵/₈ × 32 ¹/₂" (82.9 × 82.6 cm)

Edward Ruscha
American, born 1937
City. 1971
Gunpowder and pastel on paper
11 $\frac{1}{2}$ × 29" (29.2 × 73.7 cm)

The Judith Rothschild Foundation Contemporary
Drawings Collection Gift (purchase, and gift, in part,
of The Eileen and Michael Cohen Collection)

Marcel Broodthaers
Belgian, 1924–1976
Proverbe (Proverb). 1974
Gouache on printed paperboard
16 × 12" (40.6 × 30.5 cm)

Gina Pane
French, 1939–1990
Air Mail (Lettre de Turin–Lettre de Paris)
(Letter from Turin–Letter from Paris). 1970
Typewriting on two pieces of paper
Each 11 ¾ × 8 ¼" (29.8 × 21 cm)

The Judith Rothschild Foundation Contemporary
Drawings Collection Gift (purchase, and gift, in part,
of The Eileen and Michael Cohen Collection)

LETTRE DE TURIN :

Tout ici ressemble à là-bas.

Novembre 1970 GINA PANE.

LETTRE DE TURIN :

Tout ici ressemble à là-bas.

Novembre 1970 GINA PANE.

Giovanni Anselmo
Italian, born 1934
Tutto (All). 1973
Paperboard in embossed wood frame
14 $\frac{3}{4}$ × 20 $\frac{1}{2}$ × $\frac{3}{4}$" (37.5 × 52.1 × 1.9 cm)
Shown with detail

The Judith Rothschild Foundation Contemporary
Drawings Collection Gift (purchase, and gift, in part,
of The Eileen and Michael Cohen Collection)

Jannis Kounellis
Greek, born 1936
Untitled. 1962
Gouache on graph paper
27 × 39" (68.6 × 99.1 cm)

122

Alighiero e Boetti
Italian, 1940–1994
Microphone. 1965
Ink and pencil on paper
27 × 38" (68.6 × 96.5 cm)

The Judith Rothschild Foundation Contemporary
Drawings Collection Gift (purchase, and gift, in part,
of The Eileen and Michael Cohen Collection)

123

Alighiero e Boetti
Italian, 1940–1994
I sei sensi (*The Six Senses*). 1973
Ballpoint pen on six pieces of paper
39 ½" × 14' (100.3 × 426.7 cm)

126

Alighiero e Boetti
Italian, 1940–1994
Dicembre 1983 (December 1983). 1983
Pencil on paper on canvas
39 ⅛ × 50" (99.4 × 127 cm)

Giuseppe Penone
Italian, born 1947
Una pelle di spine (*A Skin of Thorns*). 2001
Pressure-sensitive tape with ink and
colored ink on paper
37 × 25" (94 × 63.5 cm)

Marisa Merz
Italian, born 1931
Untitled. c. 1996
Spray paint and pencil on paper
66 ½ × 52 ½" (168.9 × 133.4 cm)

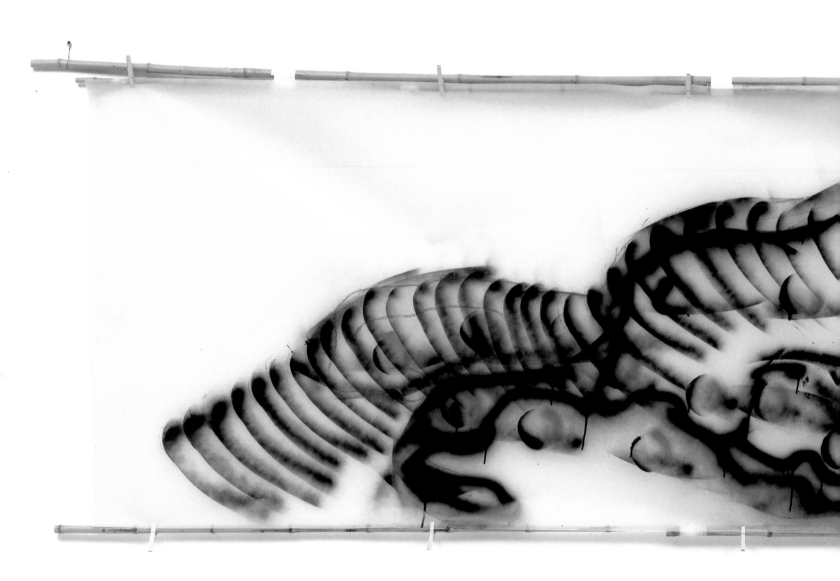

Mario Merz
Italian, 1925–2003
Untitled from *Noi giriamo intorno alle case
o girano intorno a noi? (Do We Surround The
Houses, Or Do The Houses Surround Us?)*. 1982
Spray paint and charcoal on transparentized
paper with bamboo and clothespins
48" × 13' 5 ¼" (121.9 × 409.6 cm)

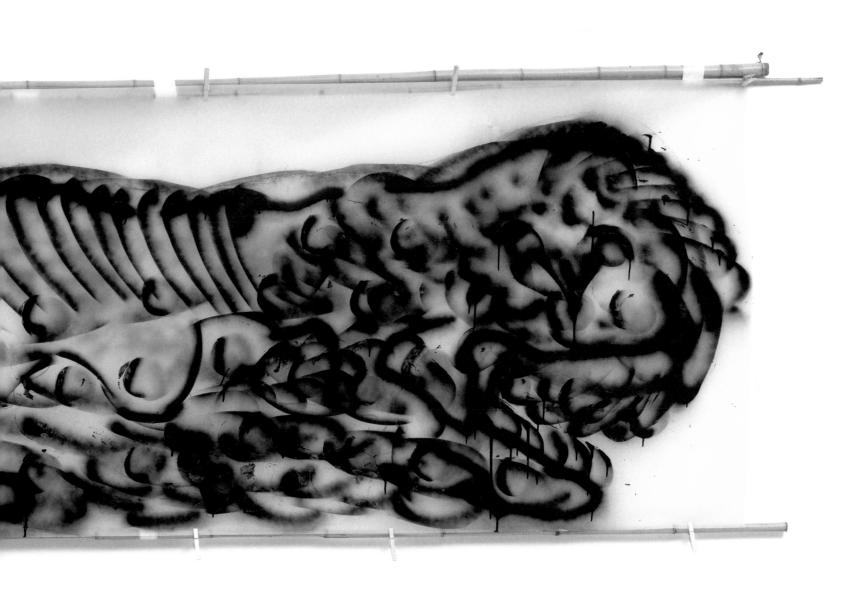

Gerhard Richter
German, born 1932
Study for *Parkstück (Park Piece)*. 1971
Oil on paper
24 × 33 ¾" (61 × 85.7 cm)

Sigmar Polke
German, born 1941
Untitled (Raster mit Gesichtern)
(Raster with Faces). 1964
Ballpoint pen on paper
11 ³⁄₄ × 8 ¹⁄₄" (29.8 × 21 cm)

The Judith Rothschild Foundation Contemporary
Drawings Collection Gift (purchase, and gift, in part,
of The Eileen and Michael Cohen Collection)

Fliegende Untertassen (Flying Saucers). 1968
Gouache on notebook paper
8 ¹⁄₈ × 5 ³⁄₄" (20.6 × 14.6 cm)

Untitled (Acht Striche) (Eight Lines). 2003
Gouache and pencil on notebook paper
8 ¹⁄₄ × 5 ⁷⁄₈" (21 × 14.9 cm)

Untitled (Treppe, Hund, Page, Dame)
(Stairs, Dog, Bellhop, Lady). 1983
Spray paint and gouache on paper
39 ¹/₈ × 27 ¹/₂" (99.4 × 69.9 cm)

Sigmar Polke
German, born 1941
Untitled. 2003
Synthetic polymer paint on paper
39 1/8 × 27 1/2" (99.4 × 69.9 cm)

Untitled. 2003
Synthetic polymer paint on paper
39 ⅛ × 27 ½" (99.4 × 69.9 cm)

Roni Horn
American, born 1955
TOP: *Was IV*. 1985/1995
Pigment, varnish, and pencil on
cut-and-pasted cardstock
31 ½ × 31 ¼" (80 × 79.4 cm)

BOTTOM: *Was V*. 1985/1995
Pigment, varnish, and pencil on
cut-and-pasted cardstock
31 × 31 ¾" (78.7 × 80.6 cm)

Untitled (Brooklyn Blue 7). 1985
Pigment and varnish
on cut-and-pasted cardstock
14 1/4 × 15" (36.2 × 38.1 cm)

Anish Kapoor
British, born India 1954
TOP: *Untitled.* 1984
Gouache and pencil on paper
12 × 18" (30.5 × 45.7 cm)

BOTTOM: *Untitled.* 1987
Gouache on paper
20 1/2 × 22" (52.1 × 55.9 cm)

TOP: *Untitled*. 2003
Pastel on paper
21 ½ × 29 ½" (54.6 × 74.9 cm)

BOTTOM: *Untitled*. 2000
Pastel on paper
26 ¼ × 39 ½" (66.7 × 100.3 cm)

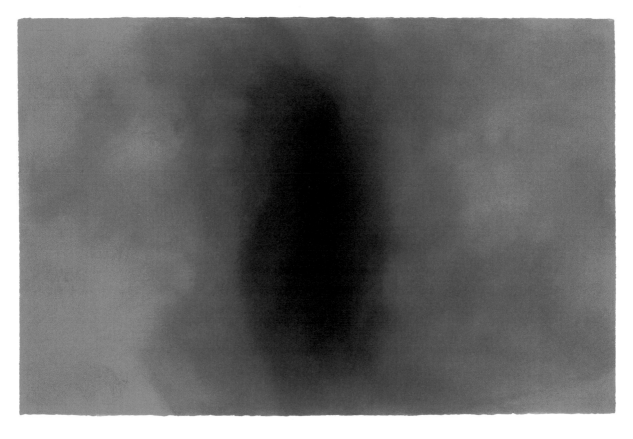

141

William Kentridge
South African, born 1955
Drawings from *Zeno Writing*. 2002
TOP: Charcoal and colored pencil on paper,
BOTTOM: charcoal, colored pencil, and
pastel on paper, FACING PAGE: charcoal and
colored pencil on paper
Each 22 ³/₈ × 30" (56.8 × 76.2 cm)

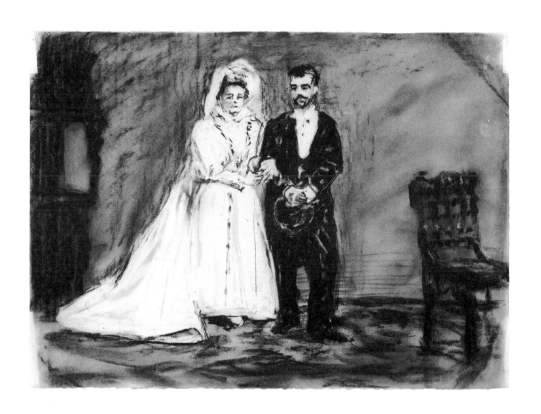

Richard Wright
British, born 1960
Untitled. 2003
Watercolor and ink on paper
10 1/8 × 14 1/8" (25.7 × 35.9 cm)

144

Untitled. 2003
Gouache, watercolor, and pencil on paper
12 ¹⁄₄ × 16" (31.1 × 40.6 cm)

Martin Creed
British, born 1968
Work No. 341. 2004
Felt-tip pen and ink on seven
pieces of paper
Each 11 ½ × 8 ¼" (29.2 × 21 cm)

Franz Ackermann
German, born 1963
Untitled (Mental Map: Peak Season). 2003
Pencil, synthetic polymer paint, ink,
and felt-tip pen on paper
27 ¹/₂ × 39 ¹/₂" (69.9 × 100.3 cm)

Mona Hatoum
British of Palestinian origin,
born Lebanon 1952
Routes II. 2002
Colored ink and gouache on five maps
CLOCKWISE FROM UPPER LEFT: 9 3/4 × 8"
(24.8 × 20.3 cm), 11 × 16" (27.9 × 40.6 cm),
11 × 8 1/2" (27.9 × 21.6 cm), 10 3/4 × 8" (27.3 ×
20.3 cm), 10 3/4 × 15" (27.3 × 38.1 cm)

149

Martin Kippenberger

German, 1953–1997

Untitled (William Blake). 1991
Cut-and-pasted printed paper
on printed paper
13 ½ × 11 ⅜" (34.3 × 28.9 cm)

Untitled (Jim Dine). 1991
Cut-and-pasted printed paper
on printed paper
13 ½ × 11 ⅜" (34.3 × 28.9 cm)

Untitled (Richard Lindner). 1991
Cut-and-pasted printed paper
on printed paper
13 ½ × 11 ⅜" (34.3 × 28.9 cm)

Untitled (Robert Rauschenberg). 1991
Cut-and-pasted printed paper
on printed paper
13 ½ × 11 ⅜" (34.3 × 28.9 cm)

Untitled (Robert Indiana). 1991
Cut-and-pasted printed paper
on printed paper
13 ½ × 11 ⅜" (34.3 × 28.9 cm)

Untitled (Jasper Johns). 1991
Cut-and-pasted printed paper
on printed paper
13 ½ × 11 ⅜" (34.3 × 28.9 cm)

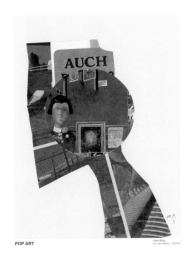

151

Thomas Schütte
German, born 1954
Mirror Drawing 14-2-99. 1999
Watercolor, colored pencil, and
pencil on paper
15 ¼ × 11 ¼" (38.7 × 28.6 cm)

Mirror Drawing 14-2-99. 1999
Watercolor and felt-tip pen on paper
15 ¼ × 11 ¼" (38.7 × 28.6 cm)

14.2.99

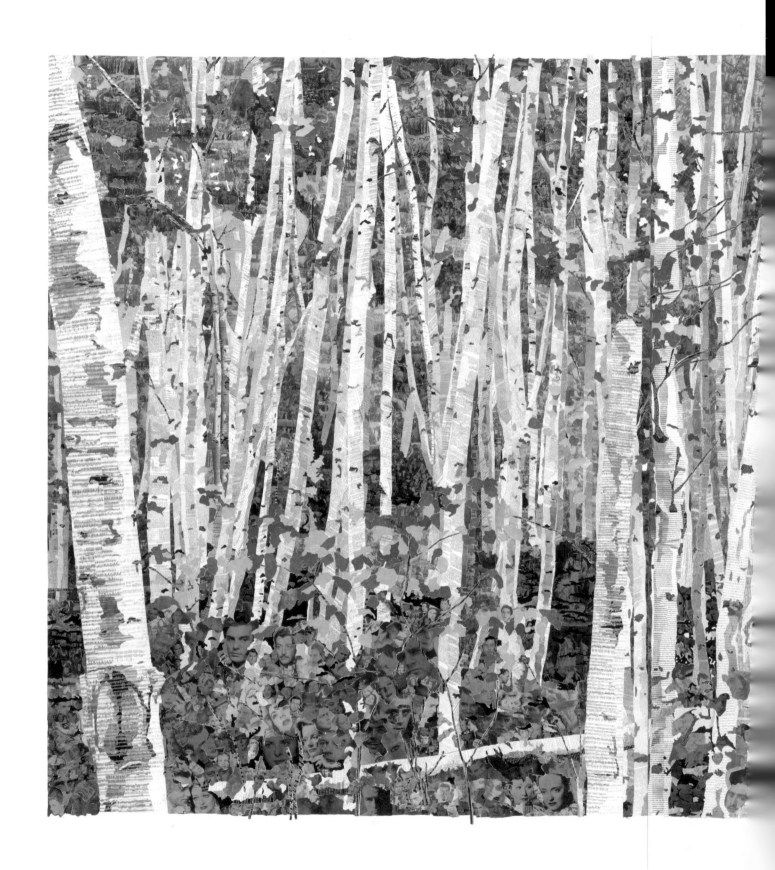

Marcel Odenbach
German, born 1953
You Can't See the Forest for the Trees. 2003
Cut-and-pasted printed paper, cut-and-pasted colored paper, ink, and pencil on two pieces of paper
7' 1 ¾" × 9' 9 ¾" (217.8 × 299.1 cm)

Rosemarie Trockel
German, born 1952
Untitled. 1994
Pencil on paper
15 × 11 ¼" (38.1 × 28.5 cm)

Albert Oehlen
German, born 1954
Untitled. 1983
Crayon on seventeen pieces of paper
Each 8 ¼ × 5 ⅞" (21 × 14.9 cm)

157

Sherrie Levine
American, born 1947
President Collage: 1. 1979
Cut-and-pasted printed paper on paper
24 × 18" (61 × 45.7 cm)

TOP LEFT: *After Arthur Dove.* 1984
Gouache, watercolor, and pencil on paper
14 × 11" (35.6 × 27.9 cm)

BOTTOM LEFT: *After Giorgio Morandi.* 1985
Gouache, ink, and pencil on paper
14 × 11" (35.6 × 27.9 cm)

RIGHT: *After El Lissitzky.* 1984
Gouache, ink, and pencil on paper
14 × 11" (35.6 × 27.9 cm)

Cady Noland
American, born 1956
Untitled Xerox Cut-Out (Squeaky Fromme/
Gerald Ford). 1993–94
Printed paper with paper clips
and pencil on paper
14 × 14" (35.6 × 35.6 cm)

SC7) SACRAMENTO, Calif., Sept. 5--SHOUTING A police as Lynette Fromme, shouts at officers being taken into custody for allegedly point was on his way from his hotel to the State C (AP Wirephoto)(see AP AAA wire story)(mw6l05 T THE OFFICERS--A woman, identified by in Sacramento, Calif. Friday after ing a gun at President Ford as he apitol building. 1975 (mbr)

Untitled (study for *Publyck Sculpture*). 1993
Pencil on transparentized paper in
artist's frame
21 ¹⁄₂ × 22 × 1" (54.6 × 55.9 × 2.5 cm)

Christopher Williams
American, born 1956
Untitled (Cafes –Intimate Grouping). 1982–83
Cut-and-taped printed paper on three pieces
of colored paper
Each 11 × 8 ½" (28 × 21.6 cm)

163

Charline von Heyl
German, born 1960
Untitled. 2003
Cut-and-pasted printed paper and ink
on fifteen pieces of paper
Each 23 ½" × 18 ¾" (59.7 × 47.6 cm)

Allen Ruppersberg

American, born 1944

TOP LEFT: *Honey, I rearranged the collection because I think it's fun. Remember the Fun Gallery in the East Village? Fun counts!* 2001
Pressure-sensitive labels and pencil on printed paper
22 × 25" (55.9 × 63.5 cm)

BOTTOM LEFT: *Honey, I rearranged the collection with artists who knew each other, but were different ages; artists who knew each other but worked differently; and artists who were influenced by artists who were soon forgotten.* 2001
Pressure-sensitive labels, transfer type, and pencil on printed paper
22 × 25" (55.9 × 63.5 cm)

RIGHT: *Honey, I rearranged the collection using artists whom we know virtually nothing about.* 2001
Pencil on printed paper
22 × 25" (55.9 × 63.5 cm)

Raymond Pettibon
American, born 1957
No Title (The bright flatness). 2003
Watercolor on paper
39 × 38 ½" (99.1 × 97.8 cm)

The bright flatness of the California landscape needs a dark, vaulted interior.

No Title (Vavoom Vavoom speaks). 1987
Ink on paper
23 ⅞ × 17 ⅞" (60.6 × 45.4 cm)

No Title (Vavoom If they). 1987
Ink on paper
24 × 18" (61 × 45.7 cm)

No Title (Vavoom The terrible). 1987
Ink on paper
23 ⅞ × 17 ⅞" (60.6 × 45.4 cm)

No Title (Vavoom Vavoom His). 1987
Ink on paper
23 ⅞ × 17 ⅞" (60.6 × 45.4 cm)

No Title (Vavoom It is). 1987
Ink on paper
24 × 18" (61 × 45.7 cm)

No Title (Vavoom A beautiful). 1987
Ink on paper
24 × 18" (61 × 45.7 cm)

Cosima von Bonin
German, born 1962
Echt hängengeblieben & aussteigen durch
drinbleiben (Really Stuck & Dropping Out
by Staying In). 2002
Chromogenic color print; felt-tip pen and
bird excrement on paper
Overall 8'11" × 14'3 ¾" (271.8 × 436.2 cm)

Robert Gober
American, born 1954
Untitled. 1981
Pencil on paper
11 × 8 ½" (27.9 × 21.6 cm)

Jeff Koons
American, born 1955
Untitled (Soccerball). 1984
Oil and pencil on graph paper
22 × 17" (55.9 × 43.2 cm)

172

Untitled (Winnie the Pooh Series). 1997
Felt-tip pen on printed paper
10 ⅞ × 8" (27.6 × 20.3 cm)

Glenn Ligon
American, born 1960
Boy on Tire, Letter C, Zululand,
Letter M #4. 2001
Oil stick on printed paper
38 × 25" (96.5 × 63.5 cm)

Boys with Basketball, Harriet Tubman,
Salimu, Letter B #3. 2001
Felt-tip pen on printed paper
38 × 25" (96.5 × 63.5 cm)

*Untitled (Stranger in the Village/
Hands #1)*. 2000
Coal dust, printing ink, and
adhesive on printed paper
38 ¹⁄₂ × 50" (97.8 × 127 cm)

Rirkrit Tiravanija
Thai, born 1961
Untitled (White Out). 1991
Corrected typewriting on two pieces
of paper on colored paperboard
26 ¹⁄₄ × 32 ³⁄₄" (66.7 × 83.2 cm)

Felix Gonzalez-Torres
American, born Cuba. 1957–1996
"Untitled" (t-cell count). 1990
Pencil, colored pencil, and gouache on
notebook paper in artist's frame
19 5/8 × 15 7/8 × 1 1/4" (49.9 × 40.3 × 3.2 cm)

Jim Hodges
American, born 1957
Happy III. 2001
Colored pencil on two pieces of paper
Overall 60 × 44 ½" (152.4 × 113 cm)

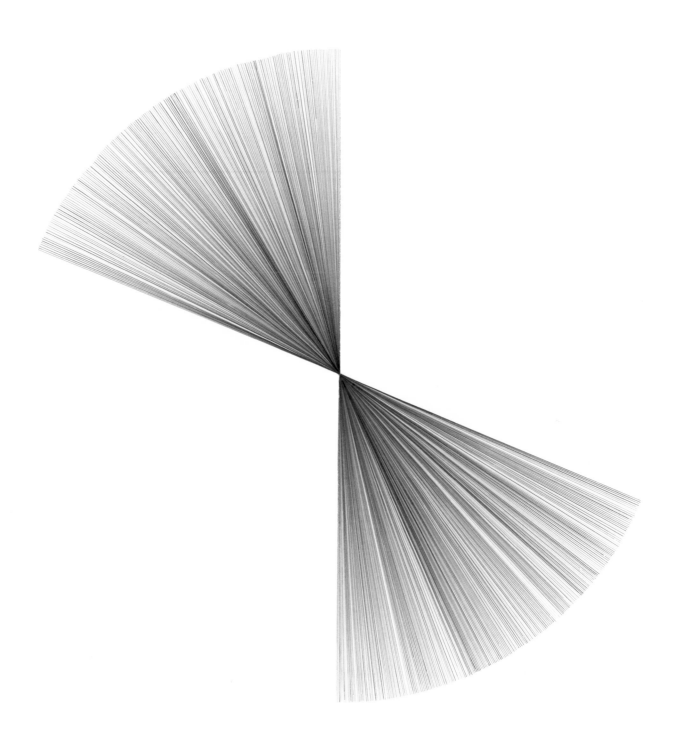

David Wojnarowicz
American, 1954–1992
Seven Miles a Second. 1988
Synthetic polymer paint, felt-tip pen,
watercolor, and postcards on
supermarket poster
43 ½ × 33 ½" (110.5 × 85.1 cm)

Jack Pierson
American, born 1960
Heroin. 1994
Cut-and-pasted printed paper
on paperboard
18 ³⁄₈ × 38 ½" (46.7 × 97.8 cm)

Kelley Walker
American, born 1969
nine disasters (Florida City; Maui; Moran;
San Fernando Valley; Anchorage; Kobe;
Elba; Los Angeles; TWA Flight 800). 2002
Nine digital files
Dimensions variable

Kelley Walker

American, born 1969

Black Star Press: Black Star, Black Star
Press, Star. 2004

Digital prints on three canvases with
silkscreened chocolate

Each 36 × 28" (91.4 × 71.1 cm)

Guyton\Walker

Wade Guyton, American, born 1972
Kelley Walker, American, born 1969
Untitled (Das Beste der Schweiz)
(The Best of Switzerland). 2004
Printed paper
11 1/2 × 8" (29.2 × 20.3 cm)

Untitled (Genève) (Geneva). 2004
Printed paper
11 1/2 × 8" (29.2 × 20.3 cm)

I'M
NOT
THAT
INNOCENT

Nate Lowman
American, born 1979
Untitled (History of the SUV –
No Blond Jokes). 2003
Installation of synthetic polymer paint,
bumper stickers, and pencil on canvas,
printed paper, and ink transfer on canvas
Overall 10' 4" × 12' 4" × 7" (315 × 375.9 ×
17.8 cm)

tegen de voortdurende economische sancties en tegen een nieuwe militaire aanval
uw financiële ondersteuning in het weekend van zaterdag - girо 33366 t.n.v. Stichting Keik de Vrede

Ik heb familie in Irak!

actie in solidariteit met de Raad van Kerken in het Midden-Oosten

Denial works for me.

Despite the high cost of living,
it's still EXTREMELY popular.

IN GODDESS
WE TRUST

The more you complain, the
longer God makes you live.

blond jokes *not* in style

a few
(history of the SUV in a inadequate descriptive
systems)

OCTOBER 23: PR maven Lizzie Grubman, who backed into a dozen people outside a
Southampton nightclub walks to court on her last day of freedom before her 60-day sentence.

Johannes Wohnseifer
German, born 1967
Into the Light. 2003
Chromogenic color print, cut-and-pasted
printed paper, and synthetic polymer
paint on magazine pages in artist's frame
13 $\frac{3}{8}$ × 18 $\frac{1}{8}$ × 1 $\frac{3}{8}$" (34 × 46 × 3.5 cm)

Monica Bonvicini
Italian, born 1965
Untitled (Duchamp). 2002
Cut-and-pasted painted paper,
cut-and-pasted printed paper,
and pencil on cut-and-pasted paper
21 × 23 ³⁄₈" (53.3 × 59.4 cm)

189

Thomas Hirschhorn
Swiss, born 1957
Provide Ruins I, III, VII, VIII. 2003
Cut-and-pasted printed paper with felt-tip pen,
ballpoint pen, and pressure-sensitive tape
on four pieces of paper wrapped in synthetic
polymer sheets
CLOCKWISE FROM UPPER LEFT: *I.* 20 × 23 ½"
(50.8 × 59.7 cm); *III.* 20 ½ × 23 ½" (52.1 ×
59.7 cm); *VIII.* 19 ¾ × 23 ½" (50.2 × 59.7 cm);
VII. 19 ⅞ × 23 3/8" (50.5 × 59.4 cm)

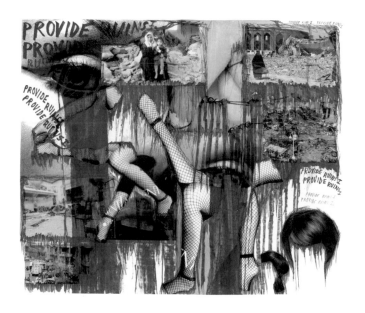

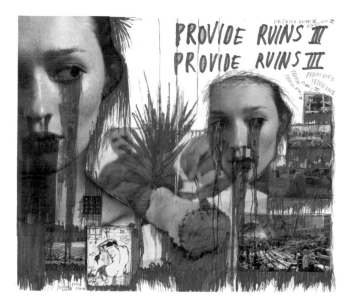

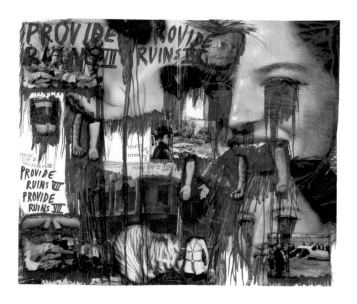

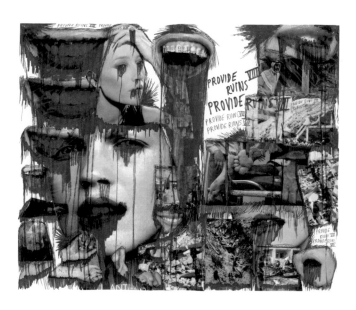

Richard Hawkins
American, born 1961

TOP LEFT: *Untitled (11)*. 1995
Cut-and-taped printed paper with felt-tip
pen and pencil on printed paper
11 × 8 ½" (27.9 × 21.6 cm)

TOP RIGHT: *Untitled (12)*. 1995
Cut-and-taped printed paper on
magazine page
10 ⅞ × 8 ¼" (27.6 × 21 cm)

BOTTOM LEFT: *Untitled (08)*. 1995
Cut-and-taped printed paper with
felt-tip pen on paper
11 × 8 ½" (27.9 × 21.6 cm)

Rachel Harrison
American, born 1966
Untitled (Oldsmobile). 2003
Felt-tip pen, colored pencil, and
cut-and-pasted chromogenic color
print on paper
11 × 13 ⁷⁄₈" (27.9 × 35.2 cm)

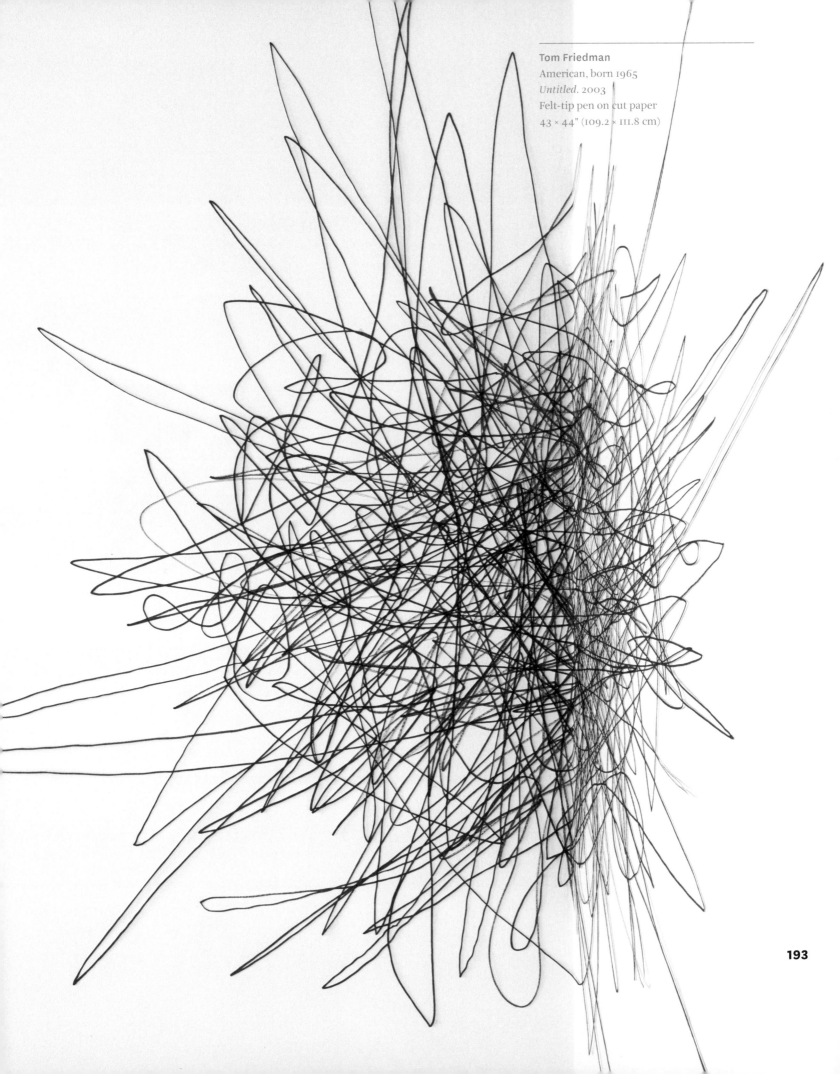

Tom Friedman
American, born 1965
Untitled. 2003
Felt-tip pen on cut paper
43 × 44" (109.2 × 111.8 cm)

Banks Violette
American, born 1973
*lines of wreckage (lovesongs for
assholes) #2*. 2003
Pencil on seven pieces of paperboard
Each 12 ¹⁄₂ × 12 ¹⁄₂" (31.8 × 31.8 cm)

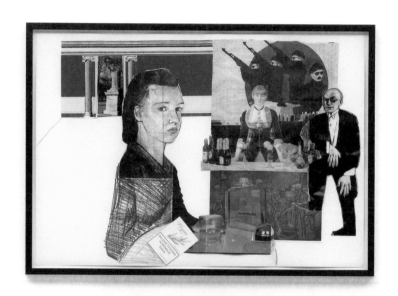

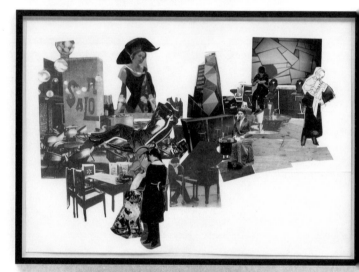

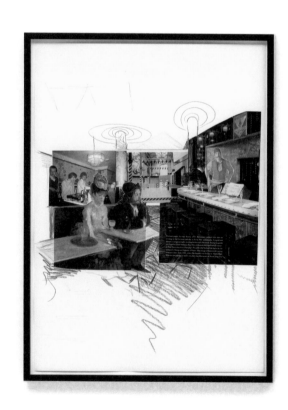

196

Lucy McKenzie
British, born 1977
Paulina Olowska
Polish, born 1976
Nova Popularna. 2003
Cut-and-pasted printed paper, cut-and-pasted chromogenic color prints, cut-and-pasted painted paper, cut-and-pasted paper, crayon, colored pencil, pencil, and ink on nine pieces of paper
CLOCKWISE FROM UPPER LEFT: 16 ½ × 23 ½" (41.9 × 59.7 cm), 11 ⅝ × 16 ⅜" (29.5 × 41.6 cm), 16 ⅜ × 23" (41.6 × 58.4 cm), 16 ⅜ × 25 ¼" (41.6 × 64.1 cm), 16 ⅜ × 23 ⅛" (41.6 × 58.7 cm), 16 ½ × 11 ½" (41.9 × 29.2 cm), 23 ⅝ × 16 ½" (60 × 41.9 cm), CENTER, LEFT TO RIGHT: 16 ½ × 23" (41.9 × 58.4 cm), 16 ½ × 11 ⅝" (41.9 × 29.5 cm)

Seb Patane
Italian, born 1970
Four Generations. 2004
Ballpoint pen on printed paper
13 ⁷⁄₈ × 9 ³⁄₄" (35.2 × 24.8 cm)

Return to Port. 2004
Ballpoint pen on printed paper
13 ⁷⁄₈ × 9 ³⁄₄" (35.2 × 24.8 cm)

Cheyney Thompson
American, born 1975

TOP: *Towel and Timber*. 2003
Synthetic polymer paint and ink on paper
17 × 14" (43.2 × 35.6 cm)

BOTTOM: *Untitled*. 2003
Ink on paper
14 × 17" (35.6 × 43.2 cm)

Wilhelm Sasnal
Polish, born 1972
Untitled. 2003
Ink and pencil on paper
11 ⁵⁄₈ × 8 ¹⁄₄" (29.5 × 21 cm)

Untitled. 2003
Ink and pencil on paper
16 ½ × 11 ⅝" (41.9 × 29.5 cm)

Untitled. 2003
Ink and pencil on paper
16 ½ × 11 ⅝" (41.9 × 29.5 cm)

Ján Mančuška
Czech, born 1972
Konference (Conference). 2001
Installation of paper, ink, graph paper,
plexiglass stands, wood boxes, buttons,
wire, paper clips, paper napkins,
pressure-sensitive stickers, toothpicks,
sugar, synthetic polymer sheet, ribbon,
gum wrappers, cigarettes, pens,
coffee cup and saucer, sugar packets,
chewing gum, and velvet on table
Overall 16' 2" × 49" × 32 ¼"
(492.8 × 124.5 × 81.9 cm)

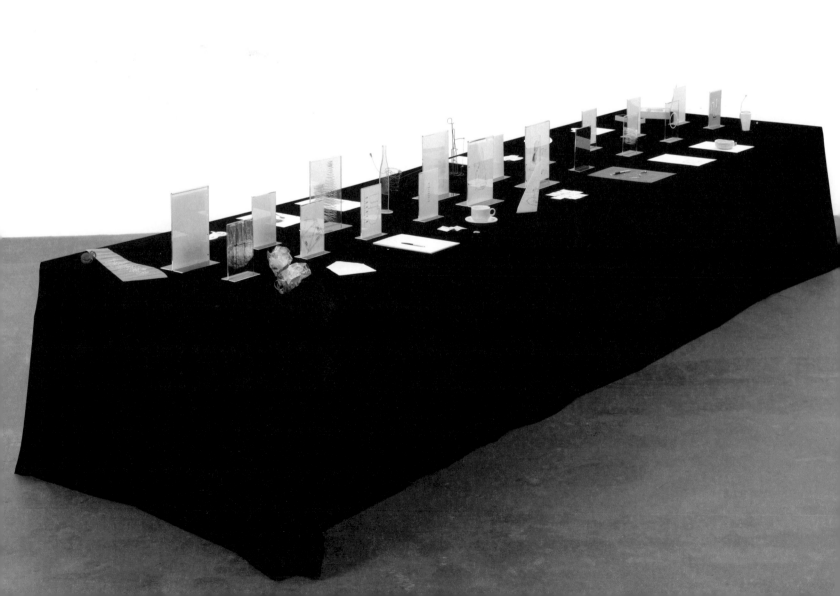

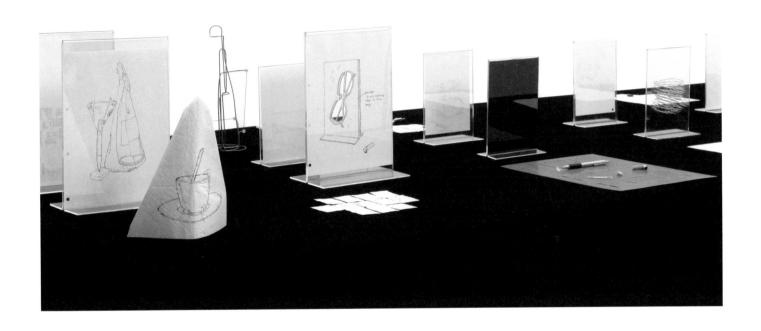

Amelie von Wulffen
German, born 1966
Untitled. 2003
Cut-and-pasted chromogenic color print,
synthetic polymer paint, and ink on paper
47 × 68 ½" (119.4 × 174 cm)

Frances Stark
American, born 1967
Untitled (Quilt with Birds and Boxes). 2004
Colored pencil, carbon paper transfer,
pencil, ballpoint pen, and felt-tip
pen on cut-and-pasted printed and
transparentized paper
60 × 33" (152.4 × 83.8 cm)

Clare Stephenson
British, born 1972
La Technique (Technique). 2003
Spray paint and pencil on paper
23 ¹⁄₄ × 33 ¹⁄₄" (59.1 × 84.5 cm)

Fernando Bryce
Peruvian, born 1965
Trotzky. 2003
Ink on ten pieces of paper
Each 16 ½ × 11 ¾" (41.9 × 29.8 cm)

Douglas Gordon
British, born 1966
Memoirs, 1984–1990. 1984–90
Ten sketchbooks and backpack
PAGES, LEFT TO RIGHT, TOP TO BOTTOM:
8 ½ × 5 ¾" (21.6 × 14.6 cm), 11 ⅜ × 8 ½"
(28.9 × 21.6 cm), 8 ½ × 6" (21.6 × 15.2 cm),
9 × 7 ¼" (22.9 × 18.4 cm), 4 ½ × 7"
(11.4 × 17.8 cm), 5 ¾ × 8 ⅛" (14.6 × 20.6 cm),
8 ½ × 6" (21.6 × 15.2 cm), 12 ¼ × 9 ½"
(31.1 × 24.1 cm), 11 ⅜ × 8 ¼" (28.9 × 21 cm),
9 × 7" (22.9 × 17.8 cm), BACKPACK: 19 ¾ × 16 ×
2 ½" (50.2 × 40.6 × 6.4 cm)

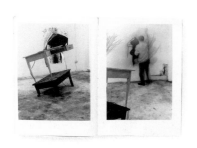

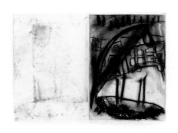

Paul P.
Canadian, born 1977
Untitled. 2003
Grease pencil and gouache on paper
6 ⁷⁄₈ × 10 ¹⁄₂" (17.5 × 26.7 cm)

Untitled. 2003
Pastel on paper
11 × 7" (27.9 × 17.8 cm)

Untitled. 2003
Colored pencil on paper
9 ¹⁄₂ × 5 ¹⁄₂" (24.1 × 14 cm)

Untitled. 2003
Grease pencil and gouache on paper
7 ¹⁄₄ × 6" (18.4 × 15.2 cm)

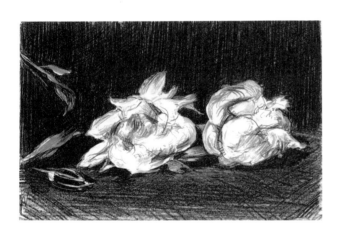

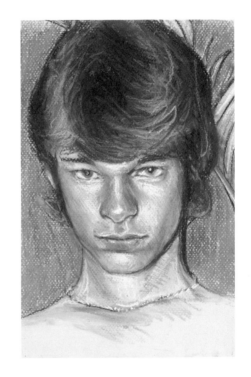

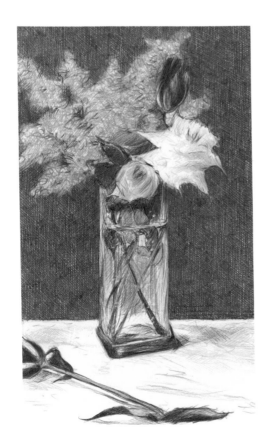

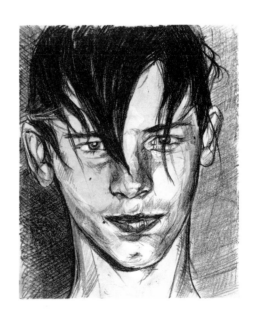

Christian Holstad
American, born 1972
*Genius Loci Reaching Gentle Heights
(Lewis in a Less-Green Room)*. 2003
Cut-and-pasted printed paper on paper
11 ¼ × 30 ⅛" (28.6 × 76.5 cm)

Christian Holstad
American, born 1972
TOP: *Mt. Rushmore*. 2003
Pencil and charcoal on erased newspaper
4 ³⁄₈ × 8 ¹⁄₄" (11.1 × 21 cm)

BOTTOM: *Kissing Couple in Jean Pants
and Green Bathroom*. 2003
Cut-and-pasted printed paper on paper
11 ³⁄₈ × 16" (28.9 × 40.6 cm)

214

Marcel van Eeden
Dutch, born 1965
Untitled. 2002
Pencil on eight pieces of paper
Each 7 ¹⁄₂ × 11 ¹⁄₈" (19 × 28.3 cm)

Mike Kelley
American, born 1954
Creationism. 1981–83
Synthetic polymer paint on four
pieces of paperboard
Each 38 × 24 ½" (96.5 × 62.2 cm)

THE MORTAL COIL
BREATHE LIFE INTO IT
IT'S THE INSPIRED COIL OF SHIT ～

CARRIED AWAY
THE PILLOW OF WIND ～
IS MEAT

EXTISPICY
READING THE BOOK OF FLESH.
THE HEAT RISING OFF IT PRODUCES
MIRAGES

Thomas Eggerer
German, born 1963
Untitled. 2004
Synthetic polymer paint and pencil on paper
48" × 7' 8 ¾" (121.9 × 235.6 cm)

219

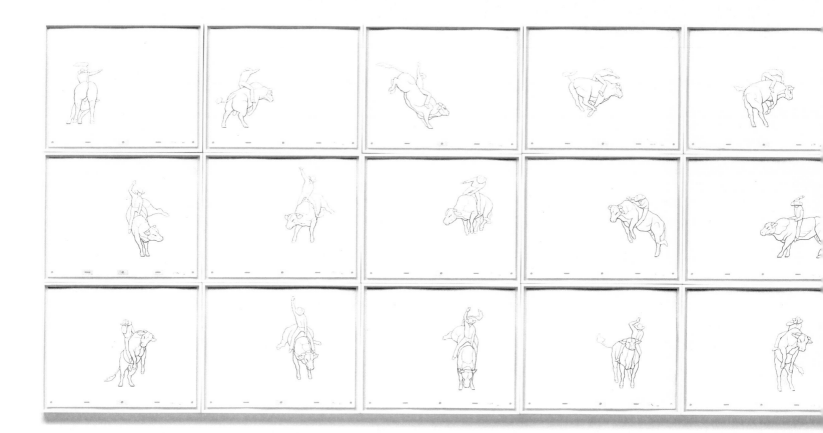

Jennifer Pastor
American, born 1966
Stills from *"The Perfect Ride" Animation.* 2003
Pencil on thirty pieces of notebook paper
Each 13 ¼ × 16 ¾" (33.7 × 42.5 cm)

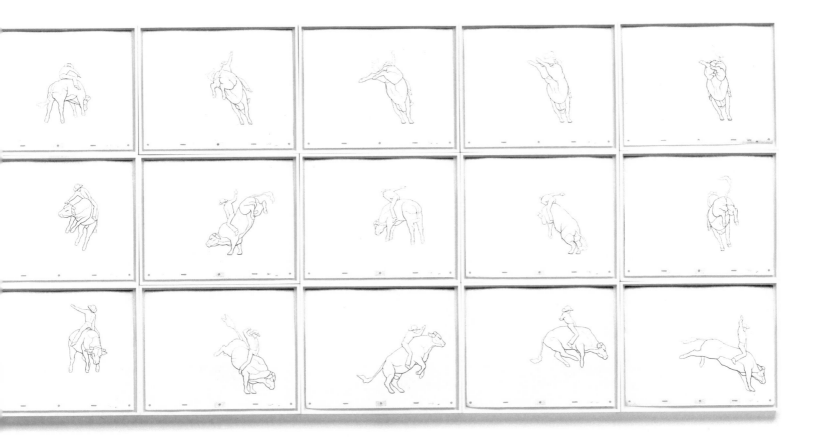

Jim Isermann
American, born 1955
Untitled 1003. 2003
Colored pencil and pencil on graph paper
17 × 22" (43.2 × 55.9 cm)

Liz Larner
American, born 1960
Untitled. 2003
Colored ink and watercolor on paper
15 × 20" (38.1 × 50.8 cm)

Jim Shaw
American, born 1952
Study for Sinnorama #1, #2, #3. 1990
Colored pencil on three pieces
of printed paper
Each 11 x 9" (27.9 × 22.9 cm)

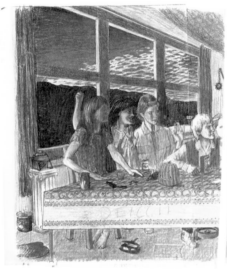 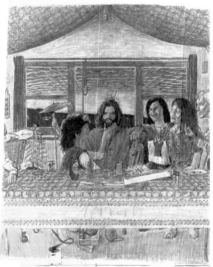

Untitled. 2003
Pencil on paper
22 ³/₈ × 30" (56.8 × 76.2 cm)

Jason Rhoades
American, 1965–2006
*Various Original Drawings from Perfect
World in Mephisto Box*. 2000
Installation of two vinyl-covered wood
boxes containing felt-tip pen on fifty-eight
pieces of paper in artist's frames
BOXES: each 17 ¾ × 46 ¾ × 26 ⅜" (45.1 ×
118.7 × 67 cm), DRAWINGS: each 17 × 11 × 2"
(43.2 × 27.9 × 5.1 cm)

Charles Ray
American, born 1953
Untitled. 2003
Felt-tip pen on paper
25 ³⁄₄ × 41" (65.4 × 104.1 cm)

"sfnwvlei"

(something from nothing with very little effort involved)

A-Z Advanced Technologies Andrea Zittel, 2002

"sfnwvlei" (something from nothing with very little effort involved) Andrea Zittel, 2002

"sfnwvlei" Andrea Zittel, 2002

228

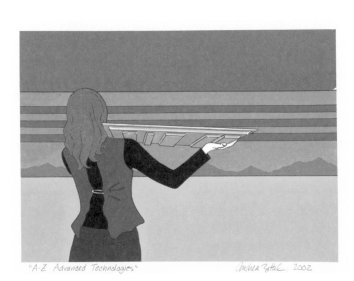

Mark Grotjahn
American, born 1968
Untitled (2 Greens Cream Black
Butterfly 74). 2002
Colored pencil on paper
24 × 19" (61 × 48.3 cm)

Untitled (Blue and Yellowish Cream
Butterfly 76). 2002
Colored pencil on paper
24 × 19" (61 × 48.3 cm)

Untitled (Cream with Black Butterfly). 2002
Colored pencil on paper
24 × 19" (61 × 48.3 cm)

Untitled (Red Butterfly 112). 2002
Colored pencil on paper
24 × 19" (61 × 48.3 cm)

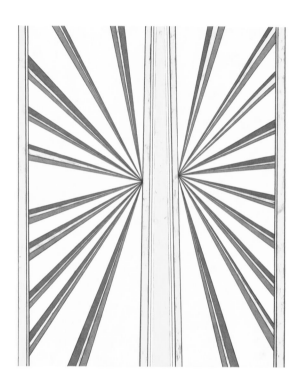

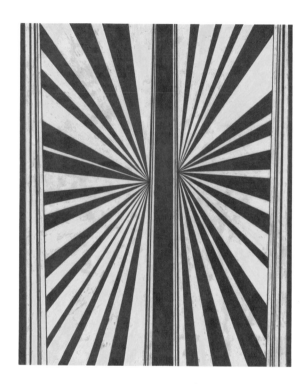

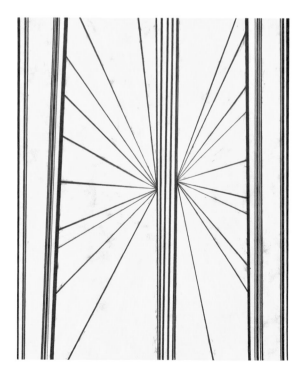

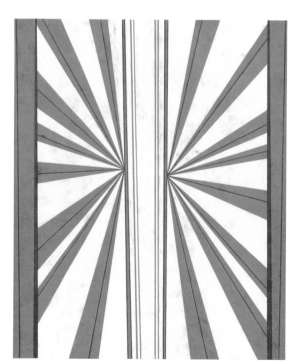

Untitled (Blue and Cream). 2000–01
Colored pencil on paper
30 × 22" (76.2 × 55.9 cm)

Jim Lambie
British, born 1964
Screamadelica. 2004
Gaffer tape and printed paper on wall
Dimensions variable
Installation view, *Jim Lambie: Mental Oyster*,
Anton Kern Gallery, New York, 2004
(shown with *Male Stripper* [2004], on floor)

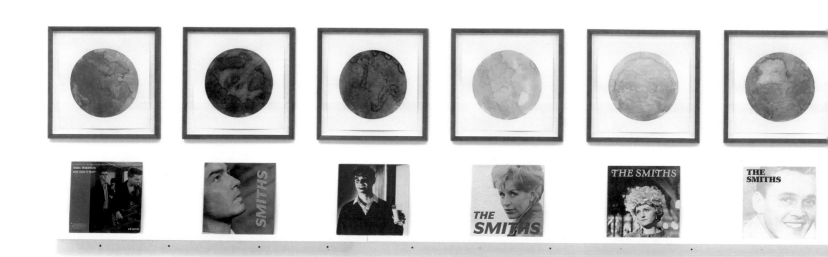

Jonathan Monk
British, born 1969
*Stop Me If You Think That You've Heard
This One Before*. 2003
Watercolor and pencil on twelve pieces
of paper with twelve 12" record albums
Overall 38 ¼" × 16' ½" × 3 ¼"
(97.2 × 489 × 8.3 cm)

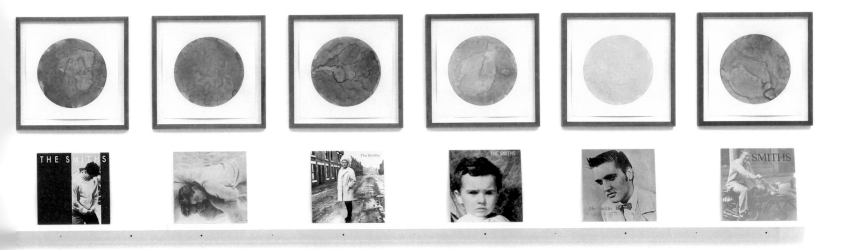

235

Monica Majoli
American, born 1963
Hanging Rubberman #2. 2003
Watercolor, gouache, and pencil on paper
63 ½ × 51 ¼" (161.3 × 130.2 cm)

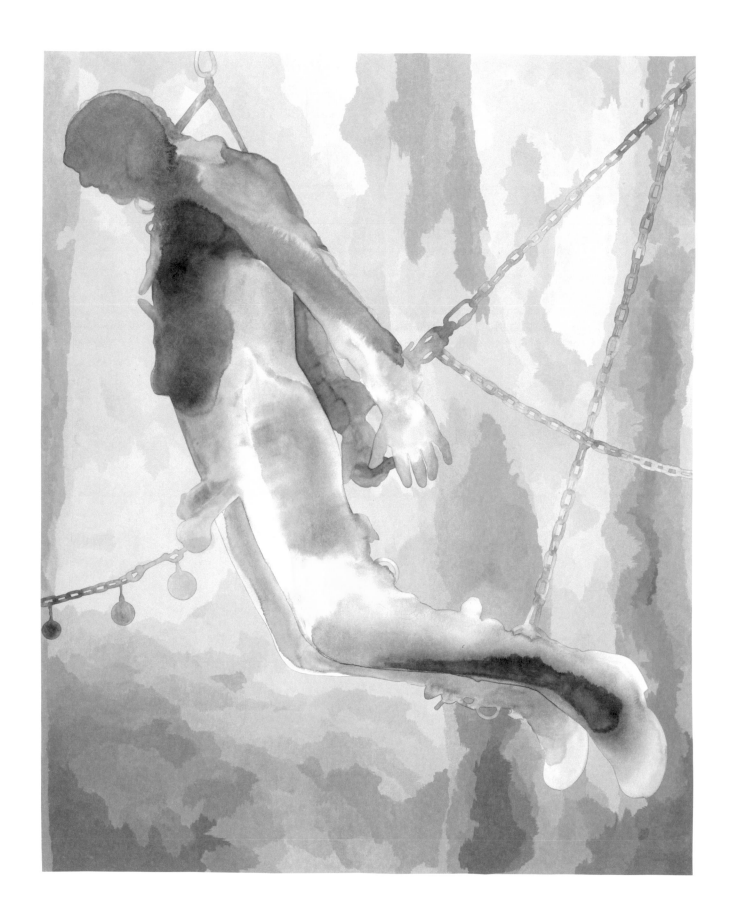

236

Lucian Freud

British, born Germany 1922

Head of Leigh. 1993

Charcoal on paper

26 ½ × 19 ¼" (67.3 × 48.9 cm)

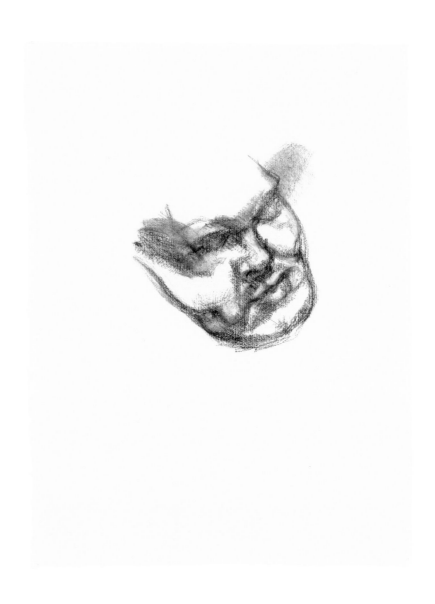

Richard Artschwager
American, born 1923
Untitled. 2002
Charcoal on paper
25 ⅛ × 24" (63.8 × 61 cm)

238

Michaël Borremans
Belgian, born 1963
The German (Part Two). 2002
Oil, watercolor, and pencil with synthetic
polymer sheet overlay on book cover
9 ³⁄₄ × 12 ¹⁄₄" (24.8 × 31.1 cm)

Tacita Dean
British, born 1965
Chère petite soeur (Dear Little Sister). 2002
Chalk on two blackboards
Each 8' × 16' (243.8 × 487.7 cm)

Russell Crotty
American, born 1956
Cassiopeia over Dry Chaparral. 2004
Ballpoint pen and watercolor
on paper mounted on fiberglass
36" (91.4 cm) diam.

Elizabeth Peyton

American, born 1965

Hockney at the RCA. 1997

Pencil on notebook paper

13 ⅞ × 11" (35.2 × 27.9 cm)

Elizabeth Peyton
American, born 1965
The Red and the Black. 1992
Charcoal and pencil on paper
16 ½ × 11 ¾" (41.9 × 29.8 cm)

Lunch (Nick). 1997
Watercolor on paper
29 7/8 × 22 1/2" (75.9 × 57.2 cm)

David Hockney
British, born 1937
Wayne Sleep. 1971
Ink on paper
17 × 13 ⅞" (43.2 × 35.2 cm)

248

Richard Hamilton
British, born 1922
Study for *A dedicated follower of fashion*. 1980
Cut-and-pasted painted paper and
cut-and-pasted gelatin silver print
with synthetic polymer paint, ink, and
pencil on paperboard
27 $\frac{1}{2}$ × 19 $\frac{5}{8}$" (69.9 × 49.8 cm)

Peter Doig
British, born 1959
Camp Forestia. 1996
Pastel on paper
7 7/8 × 9 1/2" (20 × 24.1 cm)

Screaming Cop (Echo Lake), 1998
Oil on paper
23 ½ × 16 ½" (59.7 × 41.9 cm)

Kai Althoff
German, born 1966
Stigmata aus Großmannssucht
(*Stigmata from Megalomania*). 1999
Four from a series of thirteen.
CLOCKWISE FROM UPPER LEFT: ink and
felt-tip pen on paper, 16 1/4 × 21 3/8" (41.3 ×
54.3 cm); pencil, colored pencil, watercolor,
gouache, and felt-tip pen on paper on
paper, 14 1/2 × 11 1/4" (36.8 × 28.6 cm);
ink and watercolor on paper, 11 5/8 × 11 1/2"
(29.5 × 29.2 cm); watercolor and felt-tip pen
on paper, 11 3/4 × 16 1/2" (29.8 × 41.9 cm)

Untitled. 2004
Ink, colored ink, cut-and-pasted printed
synthetic polymer sheet, and pencil on paper
14 × 16 ½" (35.6 × 41.9 cm)

Luc Tuymans
Belgian, born 1958
Untitled. 1990
Watercolor and pencil on cut-and-pasted
paper on paperboard
13 3/4 × 9 7/8" (34.9 × 25.1 cm)

Jockum Nordström
Swedish, born 1963
Who Wrote What. 2003
Cut-and-pasted colored paper, cut-and-pasted painted paper, and cut-and-pasted paper with ink, watercolor, pencil, colored pencil, and ballpoint pen on paper
39 ½ × 57 ¼" (100.3 × 145.4 cm)

Francis Alÿs
Belgian, born 1959
Untitled (Boy with Jug). 2000
Oil and pencil on cut-and-taped
transparentized paper
12 × 7 ⅞" (30.5 × 20 cm)

Untitled (Man at Table). c. 1999
Oil and pencil on cut-and-taped
transparentized paper
9 × 10" (22.9 × 25.4 cm)

Maurizio Cattelan
Italian, born 1960
Untitled (Picasso). 1998
Pencil and felt-tip pen on paper
13 × 9 ½" (33 × 24.1 cm)

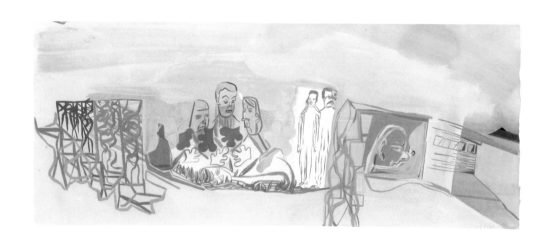

Amy Sillman
American, born 1956
Letter from Texas. 2002
Gouache on three pieces of paper
Each 17 × 40 ½" (43.2 × 102.9 cm)

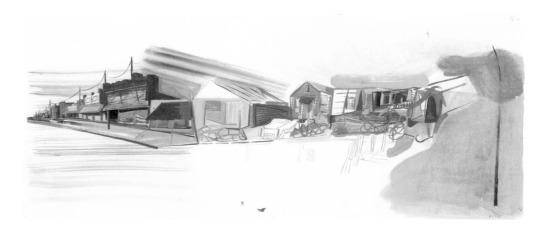

Yun-Fei Ji
Chinese, born 1963
The Empty City: Autumn Colors. 2003
Chinese watercolor and ink
on Chinese paper
31 ¹/₂" × 7' 8 ¹/₂" (80 × 235 cm)

Nicole Eisenman
American, born 1965
Raging Brook Farm. 2004
Watercolor on prepared paper
55 ½ × 59" (141 × 149.9 cm)

Arturo Herrera
Venezuelan, born 1959
Untitled. 2003
Cut-and-pasted printed paper on paper
7' 10" × 6' 1 ½" (238.8 × 186.7 cm)

Kara Walker
American, born 1969
Untitled. 2003
Seven from a series of twenty
CLOCKWISE FROM UPPER LEFT: colored ink
on paper, 12 ¼ × 9" (31.1 × 22.9 cm); colored
ink on paper, 12 ¼ × 9" (31.1 × 22.9 cm);
colored ink and ink on paper, 9 × 12 ¼"
(22.9 × 31.1 cm); synthetic polymer paint,
colored ink, and ink on paper, 9 × 12 ¼"
(22.9 × 31.1 cm); colored ink on paper,
12 ¼ × 9" (31.1 × 22.9 cm); colored ink on
paper, 12 ¼ × 9" (31.1 × 22.9 cm); colored ink
and ink on paper, 12 ¼ × 9" (31.1 × 22.9 cm)

Kerry James Marshall
American, born 1955
Study for *Vignette*. 2004
Crayon, gouache, and pencil on paper
58 ¼ × 44 ¼" (148 × 112.4 cm)

Karen Kilimnik
American, born 1955
Whispering Lely Painting. 1988
Crayon on paper
35 × 23" (88.9 × 58.4 cm)

COLOR TREASURES FOR
YOUR HAIR

TOPAZ AND
JET

. And how your hair
feels is deserving of
such ~~riche~~ riches,
Now go ahead.
En hance your
worth.

LELY

because you're worth it.

PReference by L'ORÉAL

Shahzia Sikander
Pakistani, born 1969
Candied. 2003
Six from a series of twenty
Ink, colored ink, and gouache on
prepared paper
Each 15 × 11" (38.1 × 27.9 cm)

Neo Rauch
German, born 1960
Verrat (Treason). 2003
Oil on paper
8' 4 ³⁄₈" × 6' 6 ³⁄₈" (255 × 199 cm)

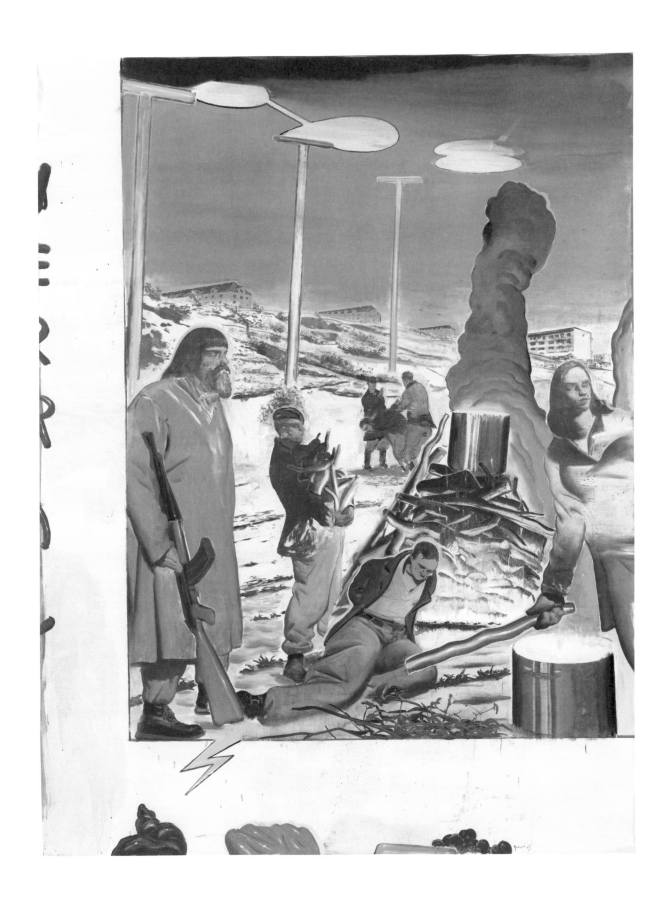

Georg Baselitz
German, born 1938
Waldarbeiter (Forest Worker). 1966
Chalk and pencil on paper
17 ½ × 12 ⅝" (44.5 × 32.1 cm)

The Judith Rothschild Foundation Contemporary
Drawings Collection Gift. Given in honor of
Gary Garrels

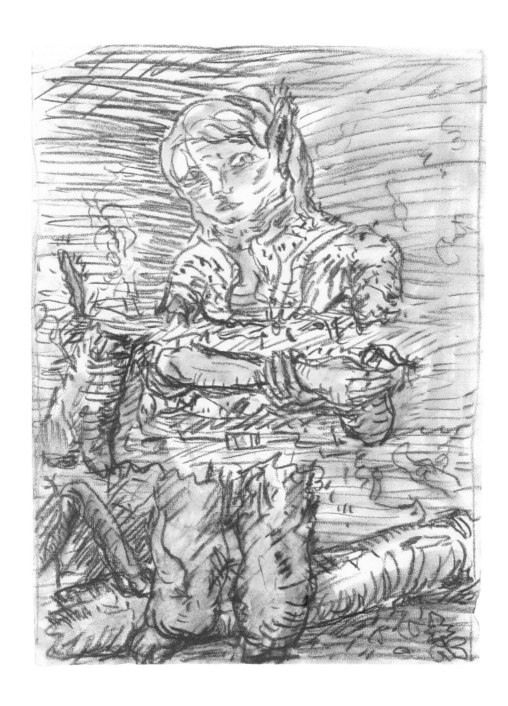

Peitschenfrau (Whip Woman). 1964
Ink on paper
24 ¾ × 19" (62.9 × 48.3 cm)

Untitled. 2001
Watercolor and ink on paper
24 ⅛ × 19 ½" (61.3 × 49.5 cm)

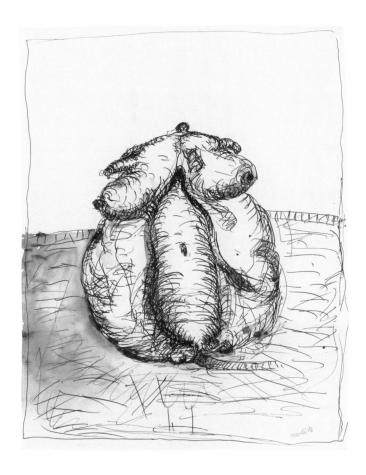

Jörg Immendorff
German, 1945–2007
Honigstand. Stützpunkt von Immendorff
(*Honey Stand: Headquarters of*
Immendorff). 1968
Felt-tip pen and ballpoint pen on paper
12 ³⁄₄ × 9" (32.4 × 22.9 cm)

Lebensmittel (1 Tüte) (Groceries [1 Bag]). 1968
Felt-tip pen, pencil, and watercolor on paper
12 ¼ × 8 ¾" (31.1 × 22.2 cm)

Markus Lüpertz
German, born 1941
Untitled (Dithyrambe) (Dithyramb). 1964
Pencil, charcoal, watercolor, and
pastel on paper
14 ½ × 25 ¼" (36.8 × 64.1 cm)

Untitled (Dithyrambe) (Dithyramb). 1964
Crayon on paper
18 × 23 ⅜" (45.7 × 59.4 cm)

Untitled (Dithyrambe) (Dithyramb). 1964
Pastel on paper
19 ¾ × 26" (50.2 × 66 cm)

Untitled (Dithyrambe) (Dithyramb). 1964
Crayon, charcoal, and pencil on paper
17 ¾ × 22" (45.1 × 55.9 cm)

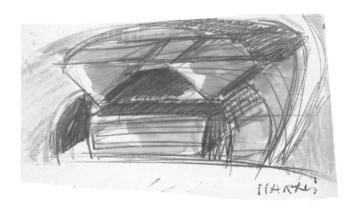

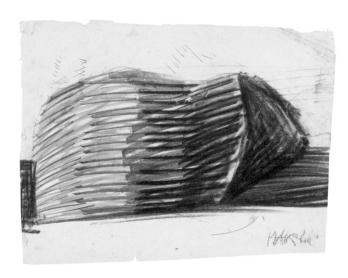

A. R. Penck (Ralf Winkler)
German, born 1939
Untitled. 1967–68
Watercolor on paper
11 ¾ × 8 ¼" (29.8 × 21 cm)

Untitled. 1974
Crayon and gouache on paper
8 ¼ × 11 ¾" (21 × 29.8 cm)

Untitled. 1967–68
Watercolor on paper
11 ¾ × 8 ¼" (29.8 × 21 cm)

Untitled (Selbstbildnis) (Self-Portrait). 1987
Gouache and watercolor on paper
8 ¼ × 11 ¾" (21 × 29.8 cm)

Per Kirkeby
Danish, born 1938
TOP: *Untitled*. 1965
Gouache, ballpoint pen, and carbon paper
transfer on paper
16 ½ × 11 ¾" (41.9 × 29.8 cm)

BOTTOM: *Untitled*. 1978
Watercolor on transparentized paper
8 ¼ × 7 ¾" (21 × 19.7 cm)

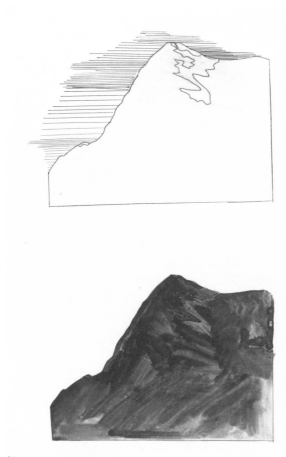

Untitled (Männerkopf) (Head of a Man). 1966
Watercolor and carbon paper transfer
on paper
16 ¹/₂ × 11 ¹/₂" (41.9 × 29.2 cm)

Franz West
Austrian, born 1947
TOP: *Untitled*. 1973
Pencil on paper
3 ¾ × 5 ⅝" (9.5 × 14.3 cm)

BOTTOM: *Arbeitsstudie im Aktionismusgeschmack (Study in the Actionist Style)*. 1974–77
Pencil, colored pencil, and pressure-sensitive tape on printed paper
8 ¼ × 11 ¾" (21 × 29.8 cm)

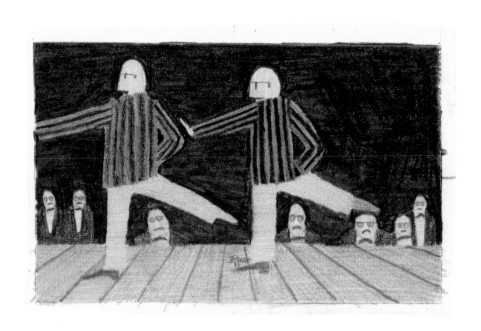

TOP: *Untitled (van Gogh)*. 1983
Gouache, synthetic polymer paint,
and ballpoint pen on printed paper on
painted cardboard in artist's frame
17 × 28 × 1 ¼" (43.2 × 71.1 × 3.2 cm)

BOTTOM: *Sammler und Jäger
(Winterkirschenernte)* (*Hunters and Gatherers
[Winter Cherries Harvest]*). 1983
Gouache and synthetic polymer paint
on printed paper in artist's frame
18 ⅞ × 34 ½ × ¾" (47.9 × 87.6 × 1.9 cm)

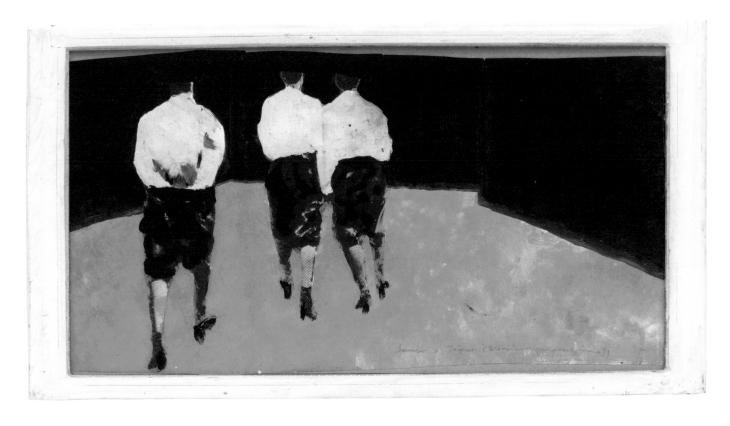

John Bock

German, born 1965

Untitled. 2002

CLOCKWISE FROM UPPER LEFT: synthetic
polymer paint, felt-tip pen, and animal
excrement on cut paper, 11 ¾ × 8 ¼" (29.8 ×
21 cm); ballpoint pen, pencil, cut-and-pasted
printed paper, and hair on cut-and-pasted
paper, 12 ½ × 8 ¼" (31.8 × 21 cm); coffee,
felt-tip pen, and cut-and-pasted printed
paper on paper, 11 ¾ × 8 ¼" (29.8 × 21 cm);
synthetic polymer toy eyeball sewn with
thread to printed paper on paper, 11 ¾ ×
8 ¾" (29.8 × 22.2 cm)

Paul McCarthy
American, born 1945
Penis Hat. 2001
Cut-and-pasted printed paper,
charcoal, pencil, and oil pastel on
cut-and-pasted paper
13' 11 ³⁄₈" × 8' 4" (425.1 × 254 cm)

John Currin
American, born 1962
Air Guitar. 2003
Gouache and colored ink on painted paper
8 ½ × 6" (21.6 × 15.2 cm)

Tom of Finland
Finnish, 1920–1991
Untitled. 1978
Pencil on paper
11 3/4 × 8 1/4" (29.8 × 21 cm)

Ele D'Artagnan
(Michele Lombardi-Toscanini)
Italian, 1911–1987
Tetradattilo con vegetazione
(#65) (*Tetradactyl with Vegetation [#65]*). 1975
Synthetic polymer paint, oil, watercolor,
and felt-tip pen on printed paper
12 ¼ × 8 ½" (31.1 × 21.6 cm)

Dr. Lakra (Jerónimo López Ramírez)
Mexican, born 1970
Untitled (Mujer con pájaros)
(Woman with Birds). 2003
Colored ink and synthetic polymer
paint with decals on magazine page
16 ½ × 10 ¼" (41.9 × 26 cm)

Untitled (Betty González). 2003
Colored ink and synthetic polymer
paint on magazine page
20 ⅜ × 14 ⅛" (51.8 × 35.9 cm)

Marcel Dzama
Canadian, born 1974
Underground. 2004
Ink, watercolor, and root beer concentrate
on twenty-five pieces of paper
28" × 22' (71.1 × 670.6 cm)
Shown with detail

Henry Darger
American, 1892–1973
RECTO: *116. At Jennie Richee. Notice by
approach of blue gray black cloud that
hurricane like thunder storm is going to renew.*
Carbon paper transfer, watercolor, and
pencil with ink on cut-and-pasted paper
VERSO: *117. At Jennie Richee. To avoid being
out in the open when storm renews, they
take chance going through farm possessed
by Glandelinian soldiers but have confidence
in protection of four Blengins.* c. 1960s
Carbon paper transfer, watercolor, pencil,
and cut-and-pasted printed paper with ink
on cut-and-pasted paper on paper
23" × 9' 1" (58.4 × 276.9 cm)

R. Crumb
American, born 1943
TOP: *God Wants Me to Draw.* 2003
Ink and correction fluid on paper
10 3/8 × 12" (26.4 × 30.5 cm)

BOTTOM: *The Complete Fritz the Cat.* 1976
Ink on paper
13 1/2 × 10 1/2" (34.3 × 26.7 cm)

H. C. Westermann
American, 1922–1981
Untitled (Death Ship in a Port). 1974
Ink and watercolor on paper
11 × 15" (27.9 × 38.1 cm)

Carroll Dunham
American, born 1949
Untitled. 1996
Pencil and crayon on paper
31 ¼ × 42" (79.4 × 106.7 cm)

Philip Guston
American, born Canada. 1913–1980
Untitled. 1968
Charcoal on paper
18 × 24" (45.7 × 61 cm)

Pearl Blauvelt
American, 1893–1987
Fireworks, 4th July. c. 1940
Colored pencil and pencil on
notebook paper
11 × 8 ½" (27.9 × 21.6 cm)

Pearl Blauvelt
American, 1893–1987
TOP: *Jewels and Lace.* c. 1940
Colored pencil and pencil on
notebook paper
8 ½ × 11" (21.6 × 27.9 cm)

BOTTOM: *Store Shelves with Yeast Cakes.* c. 1940
Colored pencil and pencil on
notebook paper
8 ½ × 10 ½" (21.6 × 26.7 cm)

James Castle
American, 1900–1977
Untitled. c. 1935
Soot and spit on cardboard
8 5/8 × 12 3/4" (21.9 × 32.4 cm)

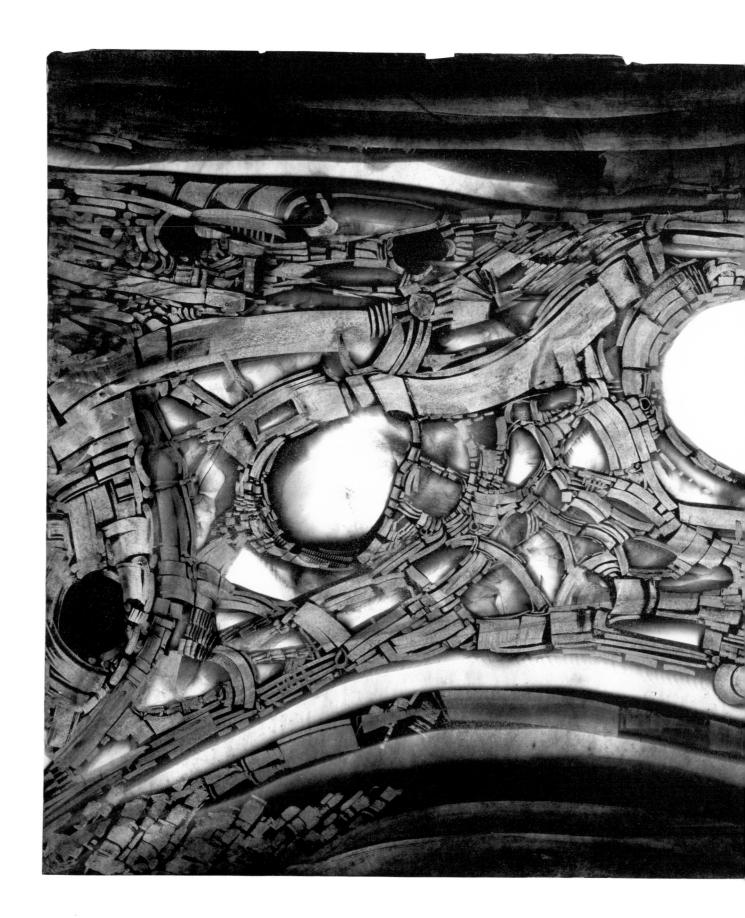

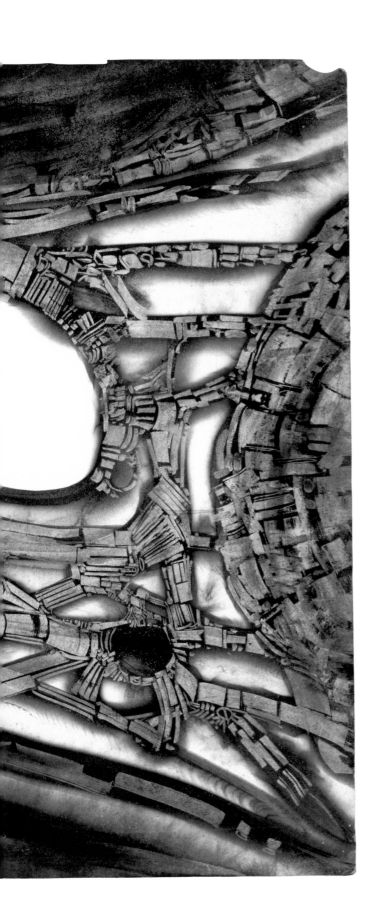

Lee Bontecou
American, born 1931
Untitled. c. 1958
Soot on paperboard
30 × 40" (76.2 × 101.6 cm)

Lee Bontecou
American, born 1931
Untitled. 1976
Pencil and colored pencil on prepared paper
15 × 11" (38.1 × 27.9 cm)

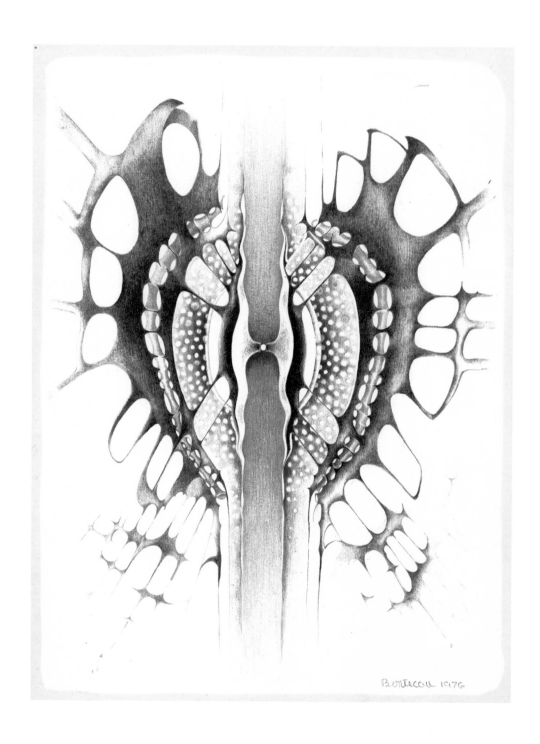

Untitled. 1998
Pastel, colored pencil, and pencil
on black paper
29 5/8 × 20" (75.2 × 50.8 cm)

Ray Johnson
American, 1927–1995
Untitled (How to Draw a Tender Button). 1974
Assemblage of printed paper, embroidered
patch, paperboard, ink, gouache, pencil, and
watercolor on painted paperboard
19 1/8 × 16 1/8" (48.6 × 41 cm)

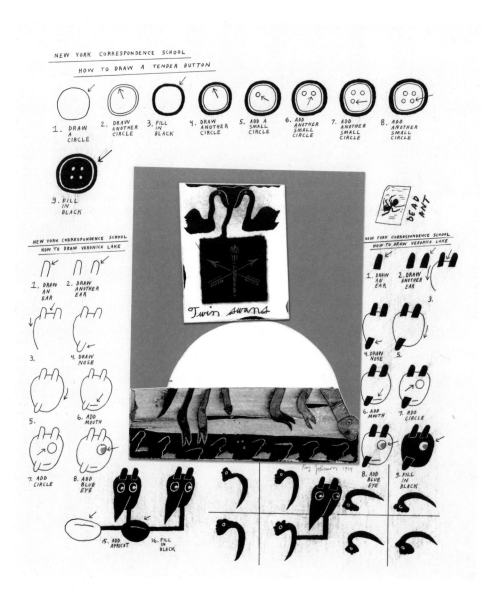

Diane Vari's Mother's Potato Masher. 1972
Assemblage of printed paper, gelatin silver
print, lace, paperboard, ink, and gouache
on painted paperboard
25 1/8 × 21 3/8" (63.8 × 54.3 cm)

Ray Johnson
American, 1927–1995
Untitled (Moticos with Everly Brothers).
1953/1994
Assemblage of printed paper, gelatin silver
print, paperboard, ink, colored pencil,
and gouache on cardboard
11 × 7 ½" (27.9 × 19.1 cm)

Bruce Conner
American, 1933–2008
ROOM. 1966
Cut-and-pasted printed paper on
printed paper on black paper
8 ½ × 11" (21.6 × 27.9 cm)

Bruce Conner
American, 1933–2008
UNTITLED. September 1, 1966
Felt-tip pen and pencil on paper
12 × 12" (30.5 × 30.5 cm)

The Judith Rothschild Foundation Contemporary
Drawings Collection Gift (purchase, and gift, in part,
of The Eileen and Michael Cohen Collection)

INKBLOT DRAWING. August 24, 1975
Ink on paper
11 ⅛ × 9 ½" (28.3 × 24.1 cm)

INKBLOT DRAWING. August 17, 1991
Ink and pencil on paper
11 ½ × 6 ½" (29.2 × 16.5 cm)

Index

Photograph Credits

Individual works of art appearing in this volume may be protected by copyright in the United States of America or elsewhere, and may not be reproduced in any form without the permission of the rights holders. In reproducing the images contained in this publication, the Museum obtained the permission of the rights holders whenever possible. In those instances where the Museum could not locate the rights holders, notwithstanding good faith efforts, it requests that any contact information concerning such rights holders be forwarded, so that they may be contacted for future editions.

Except where noted, all images © 2009 The Museum of Modern Art, New York, Digital Imaging Studio, photography by David Allison.

© 2009 Franz Ackermann: 21 (top), 148. © 2009 Kai Althoff: 252–53. © 2009 Francis Alÿs: 256. © Carl Andre / Licensed by VAGA, New York, NY: 84. © 2009 Giovanni Anselmo: 121. © 2009 Artists Rights Society (ARS), New York / DACS, London: 249. © 2009 Artists Rights Society (ARS), New York / SABAM, Brussels: 119. © 2009 Artists Rights Society (ARS), New York / VG Bild-Kunst, Bonn: 59–61, 152–53. © 2009 Richard Artschwager / Artists Rights Society (ARS), New York: 238. © 2009 Jo Baer: 72–73. © 2009 John Baldessari: 101. © 2009 Miroslaw Balka: 64–65. © 2009 Matthew Barney: 62–63. © 2009 Robert Barry: 92. © 2009 Georg Baselitz: 272–73. © Estate of Lester Beall / Licensed by VAGA, New York, NY: 293. © 2009 Norbert Bisky: 21 (bottom). © 2009 Pearl Blauvelt: 297–98. © 2009 Mel Bochner: 20. © 2009

John Bock: 282–83. © 2009 Estate of Alighiero e Boetti: 123–27. © 2009 Cosima von Bonin: 168–69. © Lee Bontecou / Courtesy Knoedler & Company, New York: 301–3. © 2009 Monica Bonvicini / Artists Rights Society (ARS), New York / VG Bild-Kunst, Germany: 189. © 2009 Michaël Borremans: 239. © 2009 Louise Bourgeois: 16. © 2009 Carol Bove: 208. © 2009 Fernando Bryce: 209. © 2009 John Cage Trust: 85. © 2009 Estate of James Castle: 299. © 2009 Maurizio Cattelan: 257. © 2009 Estate of Bruce Conner: 307–9. © 2009 Martin Creed: 146–47. © 2009 Russell Crotty: 242–43. © R. Crumb. Courtesy the artist, Paul Morris, and David Zwirner, New York: 292. © 2009 Merce Cunningham: 86. © 2009 John Currin: 284. © 2009 Amy Cutler: 22 (top). © 2009 Hanne Darboven: 96–97. © 2009 Estate of Ele D'Artagnan: 286. © 2009 Tacita Dean: 240–41. © 2009 Peter Doig: 250–51. © 2009 Carroll Dunham: 294. © 2009 Marcel Dzama: 288–89. © 2009 Marcel van Eeden: 215. © 2009 Thomas Eggerer: 218–19. © 2009 Nicole Eisenman: 262. © 2009 Öyvind Fahlström / Artists Rights Society (ARS), New York / VG Bild-Kunst, Germany: slipcase, 98–99. © 2009 Estate of Angus Fairhurst. Courtesy Sadie Coles HQ, London: 46–47. © 2009 Jackie Ferrara: 106. © 2009 Tony Fitzpatrick: 26 (top). © 2009 Estate of Dan Flavin / Artists Rights Society (ARS), New York: 67. © 2009 Lucian Freud: 237. © 2009 Tom Friedman: 193. © 2009 Isa Genzken. Courtesy the artist, David Zwirner, New York, and Galerie Daniel Buchholz, Cologne: 27. © 2009 Robert Gober: 171. © 2009 The Felix Gonzalez-Torres Foundation: 177. Courtesy Marian Goodman Gallery,

New York: 240–41. © 2009 Douglas Gordon: 210. © 2009 Mark Grotjahn: 230–31. © 2009 The Estate of Philip Guston: 295. © 2009 Guyton\Walker: 185. © 2009 David Hammons: 56. © 2009 Rachel Harrison: 192. © 2009 Mona Hatoum: 149. © 2009 Richard Hawkins: 191. © 2009 Arturo Herrera: 263. © 2009 Estate of Eva Hesse. Galerie Hauser & Wirth, Zurich: 108. © 2009 Charline von Heyl: 164. © 2009 Thomas Hirschhorn: 190. © 2009 David Hockney: 248. © 2009 Jim Hodges: 178. © 2009 Christian Holstad: 212–14. © 2009 Roni Horn: 138–39. © 2009 Estate of Douglas Huebler / Artists Rights Society (ARS), New York: 90. © 2009 Esate of Jörg Immendorff: 274–75. © 2009 Jim Isermann: 222. © 2009 Yun-Fei Ji: 260–61. © 2009 Jasper Johns / Licensed by VAGA, New York: 52–53. © 2009 Estate of Ray Johnson: 304–6. © Judd Foundation. Licensed by VAGA, New York, NY: 66. © 2009 Anish Kapoor: 140–41. © 2009 On Kawara: 93. Photography by Andy Keate, London, courtesy Sadie Coles HQ, London: 46–47. © 2009 Mike Kelley: 216–17. © 2009 Ellsworth Kelly: 80–81. © 2009 William Kentridge: 142–43. Courtesy Anton Kern Gallery, New York (Male Stripper [2004] is in the collection of the Hirshhorn Museum and Sculpture Garden, Washington, D.C.): 232–33. © 2009 Karen Kilimnik: 267. © 2009 Estate of Martin Kippenberger, Galerie Gisela Capitain, Cologne: 151. © 2009 Per Kirkeby: 278–79. © 2009 Jeff Koons: 172–73. © 2009 Jannis Kounellis: 122. © 2009 Yayoi Kusama: 83. © 2009 Dr. Lakra: 287. © 2009 Jim Lambie: 232–33. © 2009 Liz Larner: 223. © 2009 Kiyoko Lerner, all rights reserved.: 290–91. © 2009 Barry Le Va: 87.

© 2009 Sherrie Levine: 158–59. © 2009 Tom Levine: 107. © 2009 Estate of Sol LeWitt / Artists Rights Society (ARS), New York: 100. © 2009 Estate of Roy Lichtenstein: 19. © 2009 Glenn Ligon: endpapers, 174–75. © 2009 Graham Little: 23. Photography by Tom Little, courtesy Carnegie Museum of Art, Pittsburgh: 103. © 2009 Estate of Mark Lombardi: 94. © 2009 Nate Lowman: 186-187. © 2009 Estate of Lee Lozano: 105. © 2009 Sarah Lucas, photograph courtesy of the artist: 183. © 2009 Markus Lüpertz: 276. © 2009 Monica Majoli: 236. © 2009 Ján Mančuška: 201–3. © 2009 Robert Mangold / Artists Rights Society (ARS), New York: 78–79. © 2009 Brice Marden / Artists Rights Society (ARS), New York: 82. © 2009 Kerry James Marshall: 266. © 2009 Estate of Agnes Martin / Artists Rights Society (ARS), New York: 76. © 2009 Estate of Gordon Matta-Clark / Artists Rights Society (ARS), New York: 102. © 2009 Nick Mauss: 54–55. © 2009 Paul McCarthy: 281. © 2009 Lucy McKenzie and Paulina Olowska: 26 (bottom), 196–97. © 2009 Mario Merz: 130–31. © 2009 Marisa Merz: 129. © 2009 Jonathan Monk: 234–35. © 2009 Estate of Ree Morton: 109. © 2009 The Museum of Modern Art, New York, Digital Imaging Studio: 16, 17; photography by Thomas Griesel: 177, 248; photography by Jonathan Muzikar: 18. © 2009 Bruce Nauman / Artists Rights Society (ARS), New York: 115. © 2009 Cady Noland: 286, 160–61. © 2009 Jockum Nordström: 255. © 2009 Marcel Odenbach / Artists Rights Society (ARS), New York / VG Bild-Kunst, Germany: 154–55. © 2009 Albert Oehlen: 157. Photography by Gene Ogami, courtesy Shoshana Wayne Gallery,

Los Angeles: 242–43. © 2009 Gabriel Orozco: 95. © 2009 Paul P.: 211. © 2009 Blinky Palermo / Artists Rights Society (ARS), New York / VG Bild-Kunst, Germany: 74–75. © 2009 Estate of Gina Pane: 120. © 2009 Jennifer Pastor: 220–21. © 2009 Seb Patane: 198. © 2009 A. R. Penck: 277. © 2009 Giuseppe Penone / Artists Rights Society (ARS), New York / ADAGP, Paris: 128. © 2009 Raymond Pettibon: 166–67. © 2009 Elizabeth Peyton: 245–47. © 2009 Chloe Piene: 57. © 2009 Jack Pierson: 180. © 2009 Adrian Piper: 70. © 2009 Sigmar Polke: 134–37. © 2009 Neo Rauch / Artists Rights Society (ARS), New York / VG Bild-Kunst, Germany: 271. © 2009 Estate of Robert Rauschenberg / Licensed by VAGA, New York: 58. © 2009 Charles Ray: 227. © 2009 Estate of Jason Rhoades, Hauser & Wirth, and David Zwirner, New York, photograph courtesy Estate of Jason Rhoades and David Zwirner, New York: 228. © 2009 Gerhard Richter: 133. © 2009 Estate of Beatrice Riese: 22 (bottom). © 2009 Bridget Riley: 77. © 2009 Eva Rothschild: 48. © 2009 Allen Ruppersberg: 165. © 2009 Edward Ruscha: 116–17. © 2009 Lucas Samaras: 112–13. © 2009 Estate of Fred Sandback: 68-69. © 2009 Wilhelm Sasnal: 200–201. © Marsie, Emanuelle, Damon, and Andrew Scharlatt / Licensed by VAGA, New York, NY: 110–11. Photography by Oren Slor, courtesy of Feature Inc., New York: 193. © 2009 Jim Shaw: 224–25. © 2009 Shahzia Sikander: 268–69. © 2009 Amy Sillman: 258–59. © 2009 Estate of Jack Smith: 104. © 2009 Frances Stark: 206. © 2009 Clare Stephenson: 207. © 2009 Estate of Paul Thek: 103. Courtesy The Estate of André Thomkins, Hauser & Wirth, Zurich and London, © 2009

André Thomkins / Artists Rights Society (ARS), New York / PROLITTERIS, Switzerland: cover, 50–51. © 2009 Cheyney Thompson: 199. © 2009 Rirkrit Tiravanija: 176. © 2009 Tom of Finland Foundation: 285. © 2009 Rosemarie Trockel: 156. © 2009 Richard Tuttle: 71. © 2009 Luc Tuymans: 254. © 2009 Cy Twombly: 49. © 2009 Banks Violette: 194–95. © 2009 Kara Walker: 264–65. © 2009 Kelley Walker: 183–84. © 2009 Andy Warhol Foundation for the Visual Arts / Artists Rights Society (ARS), New York: 25. © 2009 Estate of Robert Watts: 88. © 2009 Lawrence Weiner / Artists Rights Society (ARS), New York: 89, 91. © 2009 John Wesley: 114. © 2009 Franz West: 280–81. © 2009 Christopher Williams: 162–63. © 2009 Johannes Wohnseifer: 188. © 2009 Estate of David Wojnarowicz: 179. © 2009 Richard Wright: 144–45. © 2009 Amelie von Wulffen: 203–5. © 2009 Andrea Zittel: 228–29.

Published in conjunction with
the exhibition *Compass in Hand:
Selections from The Judith Rothschild
Foundation Contemporary
Drawings Collection*, organized by
Christian Rattemeyer, The Harvey
S. Shipley Miller Associate Curator
in the Department of Drawings,
with Cornelia Butler, The Robert
Lehman Foundation Chief Curator
of Drawings, at The Museum
of Modern Art, New York, April 22–
July 27, 2009

BNY MELLON

This exhibition, one of a series
highlighting the Museum's
contemporary collection,
is made possible by The Bank
of New York Mellon.

The publication is made
possible by a gift from The Judith
Rothschild Foundation.

Produced by the Department
of Publications, The Museum of
Modern Art, New York

Edited by Emily Hall
Designed by Project Projects
Production by Marc Sapir

Printed and bound by
CS Graphics Pte Ltd., Singapore

This book was typeset in
Amalia (Nikola Djurek, 2005),
and National (Kris Sowersby, 2007).
The paper is 140 gsm Nordland
Woodfree.

Published by
The Museum of Modern Art
11 West 53 Street
New York, New York 10019-5497
www.moma.org

Library of Congress Control
Number: 2008943590
ISBN: 978-0-87070-745-2

Distributed in the United States
and Canada by D.A.P./Distributed Art
Publishers, Inc., 155 Sixth Avenue,
2nd floor, New York, New York 10013
www.artbooks.com

Distributed outside the United States
and Canada by Thames & Hudson Ltd.,
181 High Holborn, London WC1V 7QX
www.thamesandhudson.com

COVER: André Thomkins. *Untitled* (detail).
1965 (see pages 50–51)

ENDPAPERS: Glenn Ligon. *Untitled
(Stranger in the Village/Hands #1)* (detail).
2000 (see page 175)

Printed in Singapore